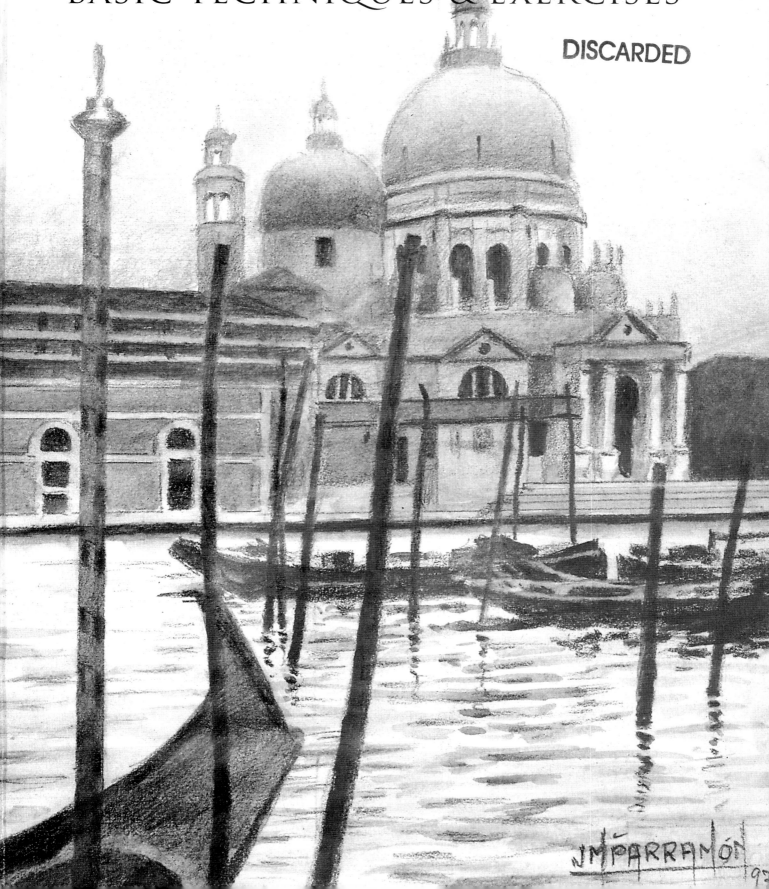

BASIC TECHNIQUES & EXERCISES

JM PARRAMÓN

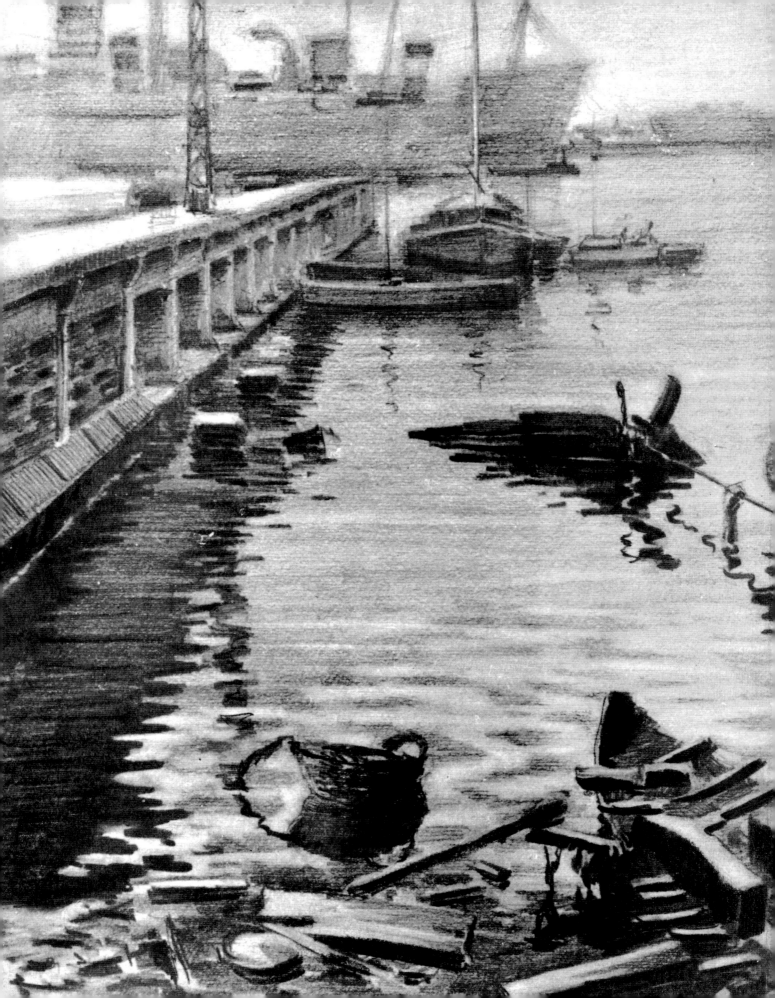

BASIC TECHNIQUES & EXERCISES

Drawing in Pencil

José M. Parramón

WATSON-GUPTILL PUBLICATIONS/NEW YORK

This edition first published in the United States in 1998
by Watson-Guptill Publications, a division of
BPI Communications, Inc., 1515 Broadway,
New York, New York 10036
Translated from the Spanish by Suzanne Stratton-Pruitt
Edited by Robbie Capp

Original Spanish edition
Editor: José M. Parramón
Text: José M. Parramón and Gabriel Martín
Production, layout, and dummy: Ediciones Lema, S.L.
Cover: Award
Photochromes and phototypesetting: Adría e Hijos, S.L.
Copyright José M. Parramón
Copyrights exclusive of production: Ediciones Lema, S.L.

Library of Congress Cataloging-in-Publication Data

Parramón, José Maria.
 [Dibujo a lápiz, English.]
 Drawing in pencil : basic techniques and exercises / José M.
Parramón ; [translated from the Spanish by Suzanne Stratton-Pruitt].
 p. cm.
 ISBN 0-8230-5128-5
 I. Pencil drawing—Technique. I. Title.
NC890.P3513 1999
741. 2'4—dc21 98-30027
 CIP

Printed in Spain
1 2 3 4 5 6 7 / 04 03 02 01 00 99 98

Table of Contents

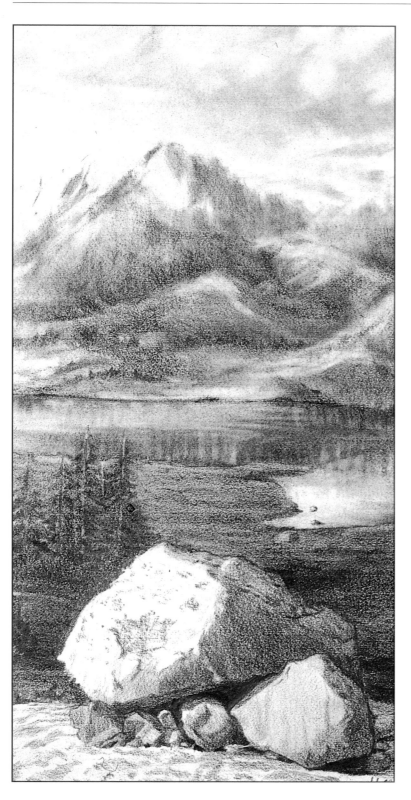

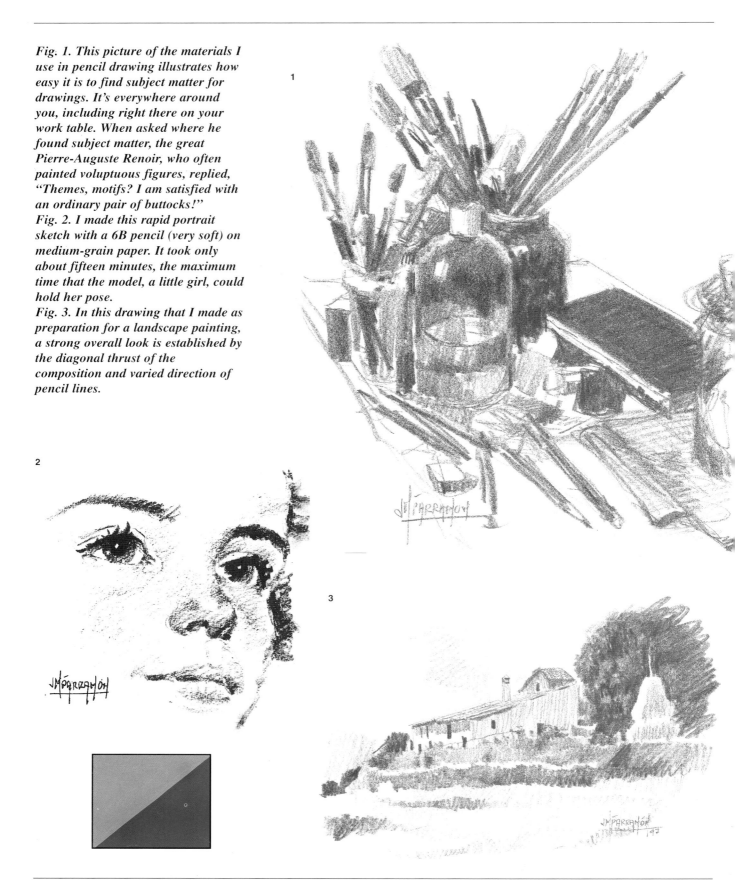

Fig. 1. This picture of the materials I use in pencil drawing illustrates how easy it is to find subject matter for drawings. It's everywhere around you, including right there on your work table. When asked where he found subject matter, the great Pierre-Auguste Renoir, who often painted voluptuous figures, replied, "Themes, motifs? I am satisfied with an ordinary pair of buttocks!"

Fig. 2. I made this rapid portrait sketch with a 6B pencil (very soft) on medium-grain paper. It took only about fifteen minutes, the maximum time that the model, a little girl, could hold her pose.

Fig. 3. In this drawing that I made as preparation for a landscape painting, a strong overall look is established by the diagonal thrust of the composition and varied direction of pencil lines.

Introduction

This is an unusual book. While its main purpose is teaching how to draw, its broad content covers much more, offering four books in one.

The first part reviews the important place that drawing has in art history through the ages, illustrated with works ranging from antiquity to the present day. The second section deals with how to furnish and light your art studio and equip it with essential drawing materials: types of papers, pencils, and other tools. In the third section, basic drawing techniques are explored to give you an understanding of everything from scale and composition to light and shadow, value and tone, contrast and atmosphere, and other fundamentals, followed by lessons for making preparatory sketches.

With the fourth part of the book, hands-on practice begins. Step-by-step demonstrations enable you to draw immediately. Starting with how to hold a drawing pencil correctly, lessons include making basic strokes; drawing with an eraser; creating a portrait with the aid of a grid; drawing rustic buildings; creating a Venetian scene using water-soluble pencil; and more. To start you off on selected exercises, a pale, preliminary sketch is imprinted on a removable sheet of paper on which you complete the drawing.

"The drawing is everything," insisted the great French painter Jean-Auguste-Dominique Ingres. "In the study of drawing, one learns proportion, character; one arrives at an understanding of human nature. One paints as one draws," Ingres asserts, for drawing is invaluable as a basic foundation to the art of painting. When we paint, we are actually drawing at the same time. To depict a tree in oil paint, for example, we use a brush and color to draw the breadth and height of the trunk, the length of the branches, the shape of the leaves. In fact, Velázquez, Titian, Rembrandt, Van Gogh, and many other masters began their pictures by painting directly on canvas, never underdrawing. They drew and painted simultaneously to avoid "overstuffing" their work, as Van Gogh put it.

Knowing how to draw will sharpen your appreciation of the colors, tones, and forms of objects you see. The art of drawing hones the ability to see nature through other eyes, through the mind and eyes of an artist. This is a skill you will develop as you practice the drawing techniques and exercises presented in these pages.

In *The Secret Love of Picasso*, written by one of the women who passed through the artist's life, Geneviève Laporte recalls Picasso telling her that "There is nothing more difficult than a line. No one knows how hard it is to invent a line. It is something very mysterious and dramatic that a simple line can represent a living thing, a woman, a man." As Picasso "blew a puff of smoke and turned his eyes upward," he concluded: "What a marvel. Isn't it more intriguing than all the magic and mysteries in the world?"

José M. Parramón

Fig. 4. José M. Parramón has written more than forty books on art instruction, which have been translated into many languages and published in countries on three continents.

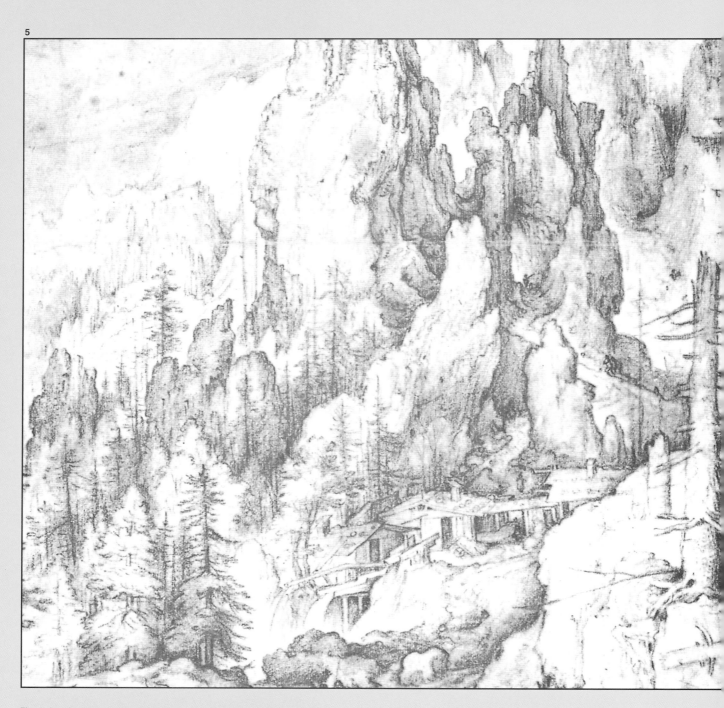

Fig. 5. Landscape artists have long enjoyed the easy of working with pencil during their travels, as evidenced by this Alpine landscape by the sixteenth–seventeeth-century Flemish artist Roelant Savery.

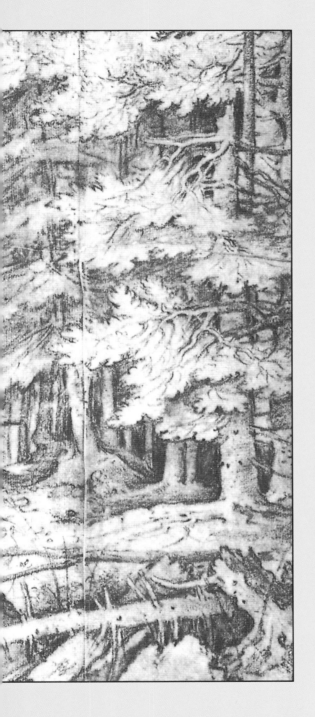

THE IMPORTANCE OF DRAWING

Drawing is an activity through which we try to represent a graphic image on a flat surface. It is the indispensable basis for any work of art in the most traditional sense of the word. Great artists know this, for the mastery of drawing has no substitute in the later development of many artistic endeavors: portraits, landscape, still life, sculpture, printmaking, architecture, and design of all kinds. But don't be intimidated thinking that special talent is needed to draw well. In the following pages, you'll see that you only need the will to learn, and with perseverence, you can become accomplished at drawing.

Drawing as the Basis for All Works of Art

Much of the success of any work of art depends directly on basic drawing skills. It's the first thing that successful artists master. Therefore, a command of these skills is integral to an artist's study and ongoing development in any plastic-arts medium. For good reason, drawing is known as the "mother and father" of all the arts.

Drawing as preparation for painting, sculpture, architecture, and printmaking has a long historical tradition. Artists from ancient times to our own have used drawings as a means of studying problems and finding solutions to the difficulties of representation. Drawing is used to establish the contours and proportions that define a real or imagined image so that it can be understood by the viewer.

Depending on their use and the time given to their creation, drawings fit various classifications: rough sketches and more finished preparatory drawings; cartoons for fresco paintings; compositional studies; and, finally, highly finished drawings that form a class of artistic creation in and of themselves.

6

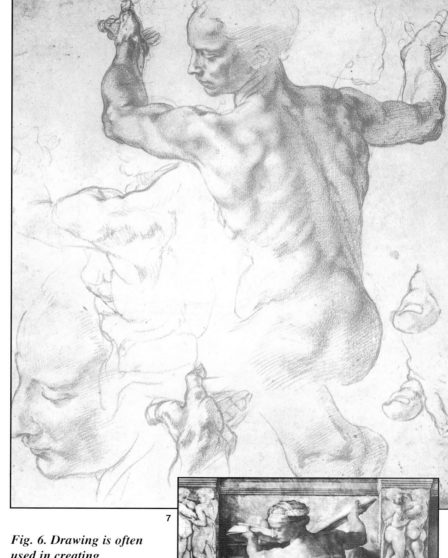

8

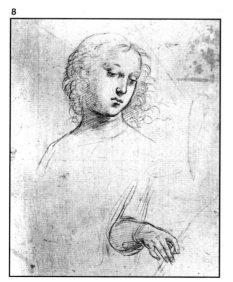

7

Fig. 6. Drawing is often used in creating preparatory studies for major works of art. In this preliminary sketch of a sibyl by Michelangelo, you can see the beginnings of the composition, the development of the figure's musculature, and fragments of various anatomical details.

Fig. 7 (facing page). Studying the Libyan sibyl painted by Michelangelo on the ceiling of the Sistine Chapel, we can see how the details shown in Fig. 6 were developed into this powerful work.
Fig. 8 (facing page). Another preliminary study is this drawing by Raphael rendered in metal point, a silver, pencil-like tool. It may have been a study for an angel in one of his great fresco paintings.

9

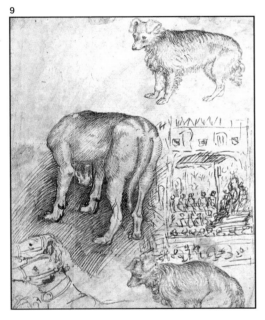

Fig. 9. These drawings of dogs, horses, and architecture on a single sheet of paper by the fifteenth-century Veronese artist Antonio Pisanello show great vitality and fulfillment of the primary objective of sketching: practice, practice, practice.
Fig. 10. Artists committed to ongoing development in their work always take along a small sketchbook for recording quick impressions. On a trip to Morocco, nineteenth-century French artist Eugène Delacroix used his notepad like a diary, making annotated sketches of anything that caught his attention.
Fig. 11. The canon of measure and scale reduced to simple geometric forms can guide the artist to an understanding of the structure of form. Here is a clear example by German artist Albrecht Dürer taken from a sixteenth-century anatomy book. Dividing the body into a series of geometric forms facilitates understanding of the symmetry and proportions that govern the human form.

To achieve a clear and simple drawing does not require genius, just motivation to learn. This book aims to make pencil drawing an activity that is both simple and pleasurable. The practical exercises described are accompanied by removable sheets of drawing paper imprinted with the first steps of each lesson. The secret is to practice the exercises suggested in the book, carrying them out carefully so that you can achieve the effects shown. Obviously, the more time you dedicate to practice, the more progress you'll make toward mastery of drawing techniques.

Once you get into the habit of drawing regularly, you'll see your work improving all the time and you'll discover how pleasant and entertaining drawing can be. In the meantime, my advice is: The best way to learn is to enjoy, enjoy, enjoy!

10

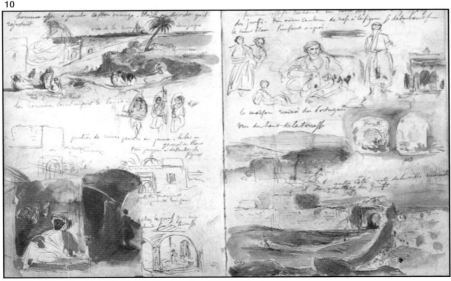

11

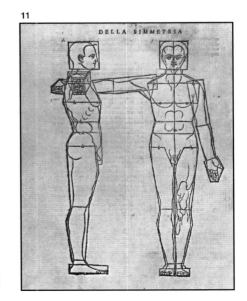

DELLA SIMMETRIA

Drawing in Prehistory and Antiquity

The first graphic signs of humanity are drawings. From the dawn of the history of art, drawing has functioned as an important means of self-expression and artistic creation.

The earliest materials used for sketches were probably burnt sticks and earth colors—ochers, reds, and grays, ground into pigments. Chunks of carbon were undoubtedly the first tools with which humans created the figures of animals on the walls of caves in which they lived, giving their drawings a certain magical and ritual value.

Centuries later, with the arrival of Greek civilization, ceramics reflected new innovations in drawing. Dating from the sixth century B.C., Greek vase painting was outstanding for the liveliness of its motifs, a narrative repertory of fantastic animals and scenes from myth and everyday life. Pliny and other early scholars document drawing as the key to wall painting, vase painting, and sculpture. They also describe students drawing on parchment or small tablets of wood, using metal points of lead and silver—implements that were distant relatives of the lead pencil. Plutarch and Herodotus tell us about the great draftsmen of the age, including Polygnotus, Phidias, Apelles, and Zeuxis.

Greek art was splendidly continued by the Romans, who mostly followed the style and iconography of their predecessors, but they also made their own innovations. Among the latter were portraits, still lifes, and the first attempts to capture the effects of perspective. Wall paintings in the houses of Herculaneum and Pompeii provide our sole extant testimony of Roman achievements in painting and drawing.

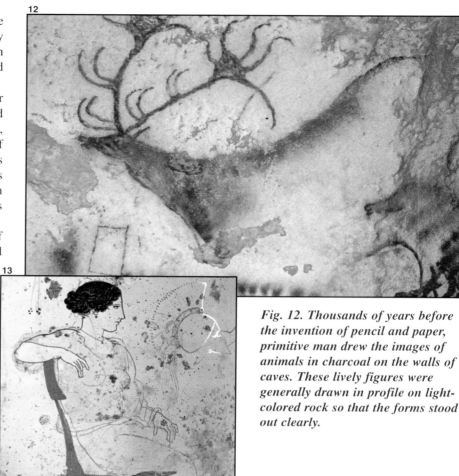

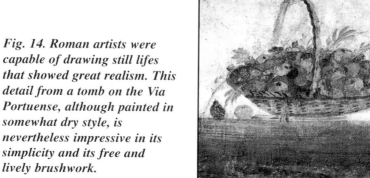

Fig. 12. Thousands of years before the invention of pencil and paper, primitive man drew the images of animals in charcoal on the walls of caves. These lively figures were generally drawn in profile on light-colored rock so that the forms stood out clearly.

Fig. 13. The development of drawing, and the arts in general, is reflected in the rich production of Greek vases over several centuries. This work, created about twenty-five hundred years ago, is outstanding for its linear contour and exquisite chromatic relationships.

Fig. 14. Roman artists were capable of drawing still lifes that showed great realism. This detail from a tomb on the Via Portuense, although painted in somewhat dry style, is nevertheless impressive in its simplicity and its free and lively brushwork.

The Middle Ages and the Invention of Paper

In the early medieval period, manuscript books began to recover the importance they lost during the "Dark Ages" in Europe. The material that was used as a support for drawing and writing was parchment, or vellum, the tanned and stretched skin of an animal. The appearance of miniature books recognized the ornamental value of a drawn or painted image illustrating the written text. During the same period, the art of calligraphy came to be valued

Fig. 15. Italian Giovanni de Grassi created this curious anthropomorphic alphabet, which reflects the important decorative role that graphics played during the Middle Ages.

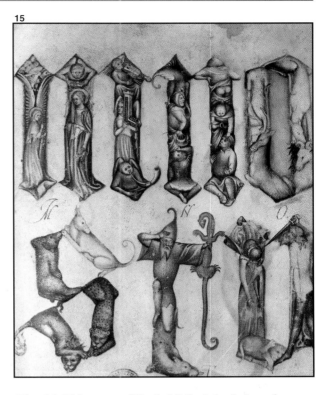

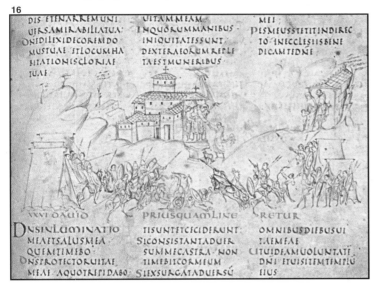

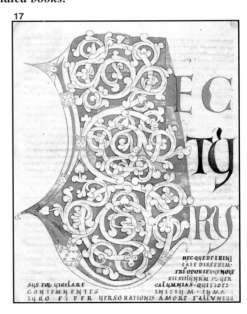

Fig. 16. This page of lively biblical depictions from the Utrecht Psalter exemplifies a moment in the development of books from manuscript to illustrated form.

Fig. 17. An ornate initial letter created at the Scriptorium of the All Saints Monastery in Germany dating from the eleventh century typifies the decorative capital letters that ornamented codexes and illuminated books.

as much as drawing itself. The decorative function of writing is particularly notable in the design of capital letters that began a chapter or page. These were often inspired by arabesques with plant and animal motifs, and the design of these letters came to play as important a role as drawings that illustrated the text. Studies have shown that preparatory drawings were still done with a metal point, called a stylus, on small wooden panels or pieces of parchment that were prepared with powdered bone and gum arabic.

Several schools of miniaturists are particularly notable. Those working in the area that is present-day Ireland produced great works such as the Book of Kells ; the school of Paris was comprised largely of Flemish artists;

and the school established by the Spanish king Alfonso X, "The Wise," brought together Christian, Jewish, and Muslim scribes. It was the Moors who brought methods of papermaking, begun in A.D. 105 in China, to the Iberian peninsula in the twelfth century. The spread of papermaking to the rest of Europe was of vital importance to the development of drawing, and paper soon became the preferred support for the medium.

The Renaissance and the Gold Age of Drawing

It isn't easy to find drawings created before the Renaissance. Many were lost because they weren't valued in and of themselves; they were considered merely preparatory studies for works of greater importance. In the fifteenth century, however, a lively interest in all facets of drawing emerged. Renaissance artists reevaluated drawing, considering it an art in itself. The availability of a better quality of paper paralleled the appearance of new drawing materials. Besides metal point and charcoal, which were already known, artists began to draw with red chalk, pen and ink, the brush, watercolor, and gouache.

Structural renderings by the great architects Leon Battista Alberti and Filippo Brunelleschi stimulated an interest in the representation of three-dimensional space and the laws that rule perspective—a decisive development for the art of drawing. Master painters such as Leonardo da Vinci and Michelangelo studied and developed the principles of drawing human anatomy, a discipline unknown until then.

Fresco painting became easier, thanks to the use of "cartoons," large-scale preparatory drawings that were used as stencils. The outlines of figures were perforated with little holes through which chalk powder was pounced, or rubbed, directly onto the wall to be painted. Before the innovation of making cartoons on paper, drawings had to be made directly on the walls to be painted.

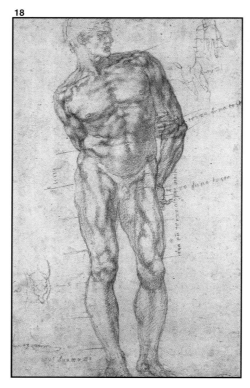

If the spread of papermaking was of great importance for drawing, perhaps even more significant was the spread of printing processes that made it possible for works of great masters to be made widely available through copies engraved on paper.

Fig. 18. Drawing the human figure has attracted artists to the study of anatomy for many centuries. In this representation of a male nude by Michelangelo, observe that the master has added some brief margin notes relating to correct proportions in drawing the musculature of the model.

Fig. 19. This arcade design by sixteenth-century Italian architect Lodovico Cigoli is a fine example of perspective rendering. Studying such perspective renderings enables artists to analyze how we perceive and depict objects receding in space.

Fig. 20. The biblical account of Esau and Jacob inspired this drawing by the fifteenth-century Florentine painter Benozzo Gozzoli. This sinopia, or preparatory drawing, was used to map out the composition of a fresco, or wall painting.

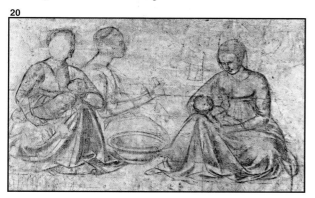

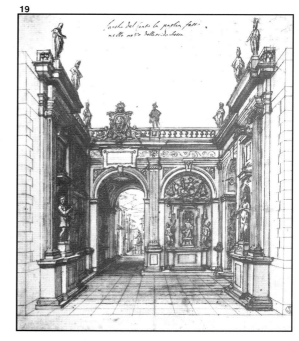

Graphite Pencils Invented in the 18th Century

21

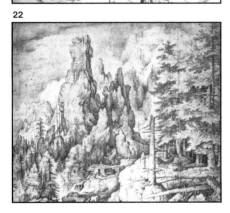

22

"Lead" pencils are actually made of graphite. They originated in the 1560s with the discovery, in a coal mine in Cumberland, England, of a black mineral having a metallic sheen that was mistakenly thought to be lead, but was composed of nearly pure carbon. It was soon found that the substance made marks easily on paper, but it took two hundred years more before graphite, or "lead" pencils, came into wide use.

In the eighteenth century, graphite began to arrive in France, where it was converted into little sticks for drawing. In 1792, following a break in diplomatic relations between England and France, exports ceased. The French engineer and chemist Jacques Conté,

motivated by the scarcity of graphite, invented a way to extend that material by mixing it with powdered chalk. He covered the stick of this new material with cedar wood and called it a Conté crayon—the French word for pencil.

Throughout the past two centuries, the characteristics of the lead pencil have been both preserved and improved. Today, the market offers pencils of various qualities, hardness, and gradations.

23

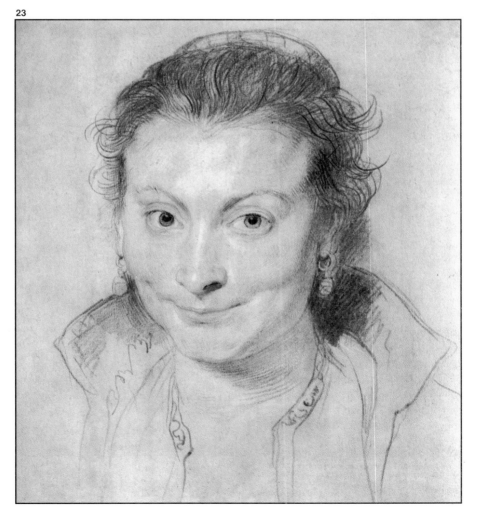

Fig. 21. In this study of a horseback rider by seventeenth-century Dutch painter Adriaen van de Velde, the artist's mastery of line is evident, as is his ability to use rich shading to impart volume to the figure.

Fig. 22. When the "lead" (actually, graphite) pencil came into use in seventeenth-century Europe, it became the indispensable tool of artists who traveled widely to draw landscapes that were then transformed into engravings that were sold as prints and published in illustrated books of the time. This example of an Alpine landscape is by the Flemish artist Roelant Savery.

Fig. 23. One of the greatest representatives of the voluptuousness of Baroque art was the Flemish painter Peter Paul Rubens. This drawing, dated 1626, is a portrait of the artist's first wife, Isabella Brandt.

Drawing in the 18th and 19th Centuries

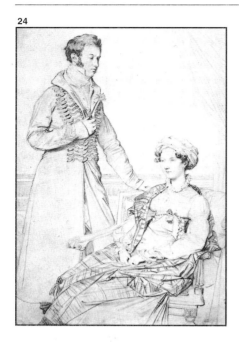

Fig. 24. This 1816 drawing of John Hay and his sister Mary is by Jean-Auguste-Dominique Ingres, one of the great representatives of Neoclassicism.

Drawing in the eighteenth century was dominated by the personalities of true geniuses such as Francisco de Goya, Giovanni Battista Tiepolo, and Antoine Watteau.

In Watteau's hands, drawing was used to represent sensuous, intimate, and delicate scenes marked by luxurious and elaborate ornament. Years later, Tiepolo, the last of the great Venetian fresco painters, often included airborne figures in his perfectly composed works. His virtuosity with decorative effects and other aspects of his extraordinary imagination are seen on the walls of chapels and palaces covered with his mythological and religious scenes.

Before and after the turn of the nineteenth century, Goya created hundreds of drawings and prints of strongly social and ideological subjects whose quality and transcendence have been recognized worldwide. And Alessandro Magnasco, now little known as an artist, but perhaps one of the greatest draftsmen of his time, created drawings with a proto-Romantic sensibility. His characters,

rendered with a touch that might be called impressionistic, are phantasmagorical and frightening.

At the end of the eighteenth century, Jacques-Louis David established the norms of Neoclassicism, based on the classical inheritance from Greece and Rome. Jean-Auguste-Dominique Ingres, the foremost representative of that style and an exceptional draftsman, left many studies and portraits executed in pencil.

During the nineteenth century, the Romantics emphasized the dramatic possibilities of great historical dramas showing the vastness of nature, solitude, and death. These qualities are found in the work of the writer and draftsman William Blake and of illustrator Honoré Daumier.

Nineteenth-century art closed with Impressionism, and monochromatic drawings gave way to compositions in color. This trend can be seen in the works of Edgar Degas, especially his extraordinary pastel drawings of ballerinas, and in Henri de Toulouse-Lautrec's creations in pastel and gouache.

Fig. 25. For Descending from Jews by Francisco de Goya is one of the eighteenth-century artist's many prints that expressively illustrate the brutal repression of the Spanish Inquisition.

Fig. 26. This study by Henri de Toulouse-Lautrec is one of the most important works of the nineteenth-century French artist's later years. Note that even though the facial features are drawn with minimal use of line, the woman's face is dramatically alive and richly expressive.

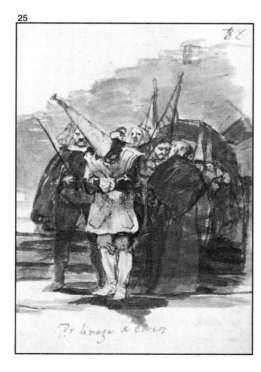

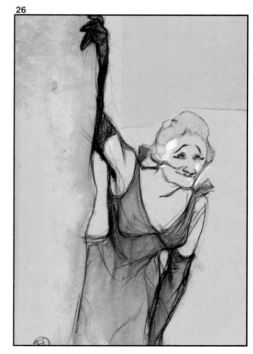

Drawing in the 20th Century

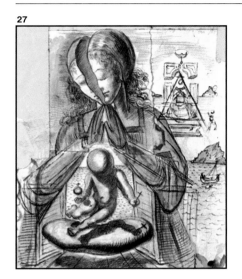

27

Art in the twentieth century is marked by a succession of visual languages that present a constantly changing panorama. Drawing has accompanied each of the avant-garde artistic movements that have flowered across ten decades. Of the many fine draftsmen of the present century, we will mention only a few representative artists.

Henri Matisse drew strongly outlined forms in bright colors, his style especially evident in his depiction of flat, decorative motifs with arabesques. Pablo Picasso mastered a wide range of styles through his long lifetime. He could draw in a purely classical manner and equally well in the abstracted forms he innovated. In drawings by the Austrian Egon Schiele, the severe angular lines of his human figures reflect an emotional tension associated with Expressionism. The Surrealism of Salvador Dalí, who created a new iconographic language from the world of dreams, expressed itself in paintings in which the skill of drawing is as important as the pictorial whole. Larry Rivers is an American contemporary painter whose excellent draftsmanship serves his adaptations of old masters' works.

We end this brief review with the British artist David Hockney, who began with an interest in Pop Art, but has since turned to a more direct and realistic imagery. His portraits are remarkable for both their naturalism and touches of humor.

Fig. 27. **Madonna de Port Lligat** *by twentieth-century Spanish painter Salvador Dalí uses brilliantly expressive lines to portray an enigmatic fantasy.*
Fig. 28. **Spanish Woman with a Fan** *is an early drawing by the twentieth-century French master Henri Matisse, who used it as a compositional study for a later painting.*

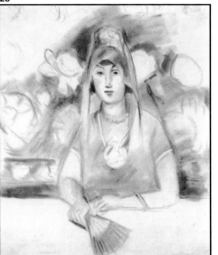

28

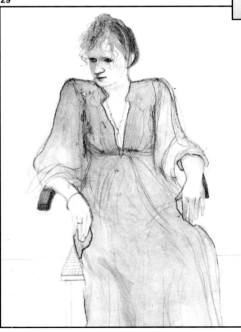

29

Fig. 29. **Celia,** *by David Hockney, was drawn in 1973, during a period when the British artist's work was largely representational.*
Fig. 30. **Nude Girl Reclining** *by Austrian Egon Schiele was drawn in 1910 and is characteristic of his portrayal of nudes who often display a desperate and solitary eroticism.*

30

Variations in Pencil Drawing

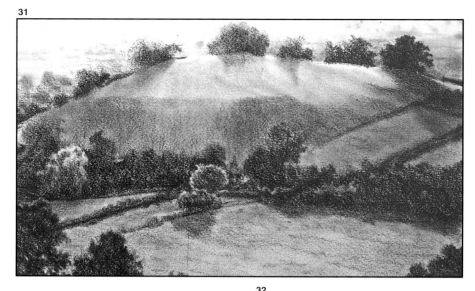

Up to now, I've emphasized how indispensable drawing is as an early, integral step in creating any work of visual art. But in addition to its helping role in creating art, drawing must be considered as an independent art form whose sole objective is its own life: the graphic representation of an image. For you to achieve mastery and ease in that realm, you should be familiar with the array of possibilities that the drawing medium offers.

It's surprising to find that a method as precise and deliberate as drawing can be practiced with just a few simple materials that are within reach of anyone who wants to try. A pencil and piece of paper are all you need to reproduce a simple object in one color, generally black on white. During the learning process, an ordinary graphite pencil is the tool I'd recommend because it's so easy to use. Little preparation is needed and the line it produces is both spontaneous and precise, qualities that make it an ideal medium for practice drawings.

Using a pencil, you'll not only be able to produce the sinuous gesture of the basic lines that structure a drawing, but also achieve beautiful tonalities that range from the softest shadow to the darkest. These tonalities, unlimited in pencil drawing, and the instructions for achieving them, are found in the pages ahead.

As for subject matter, you can choose virtually anything to draw, but

Fig. 31. This scene drawn with a soft pencil by Ester Llaudet conveys a sense of depth through the artist's use of lighter tones as the landscape recedes.

Fig. 32. A pencil study for **The Turkish Bath** *by Jean-Auguste-Dominique Ingres illustrates the master artist's use of delicate line and deft shading in drawing the human figure.*

Fig. 33. These portraits of his sons by sixteenth-century German artist Hans Holbein show how expressive even preliminary sketches can be in the hands of a master.

Fig. 34. Sepia tones heighten the beauty of this drawing by Spaniard Enric Ferau Alsina, created in about 1867.

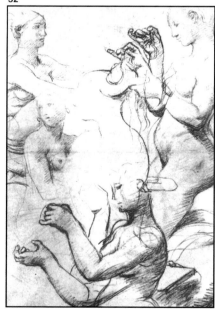

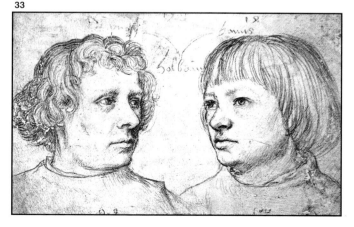

I suggest that you take your pencils, paper, and a rigid support, and begin to draw still lifes of simple objects. As you develop your skills, try landscapes, interiors, marine scenes, cityscapes, figures, and portraits. Some subjects will prove more suited to pencil than others. This book shows examples of the many possibilities offered by the medium. Only by trying a variety of subjects will you discover which are your preferences.

Fig. 35. This pencil drawing shows a corner of the studio in my country house.

35

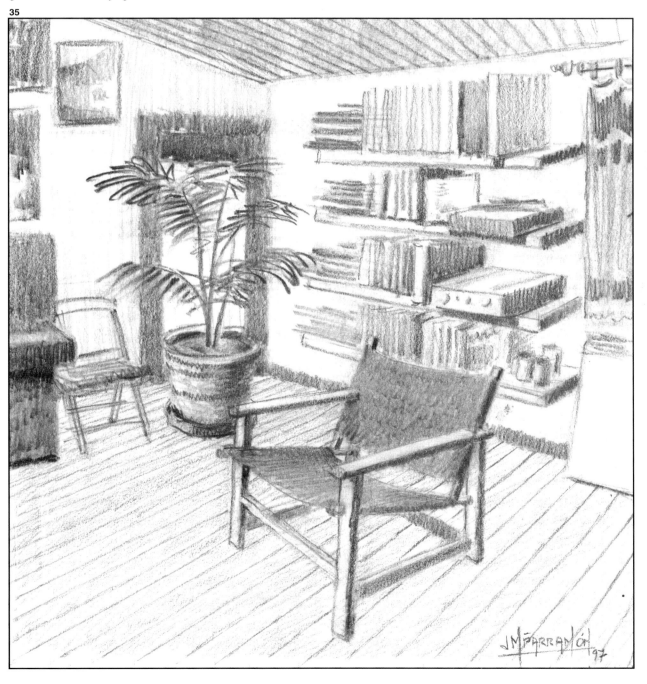

Fig. 36. The basic materials for drawing are simply pencil and paper, but one way to bring variety to your work in this medium is to make use of different kinds of papers, ranging from the ones with smooth surfaces to those with very rough textures.

MATERIALS
AND
TOOLS

Pencil drawing is an artistic activity that offers satisfying and often surprising results via a medium that is always easily at hand. To begin practicing, you need only two things: a pencil and a piece of paper. Of course, you're already accustomed to using a pencil in your daily activities. But for drawing, other complementary tools are of great importance in deriving the most from the medium and in working comfortably and efficiently. These will be introduced to you on the following pages.

The Art Studio

Painters usually require large studio space in which to work, but for pencil drawing, whether you're a beginner or an experienced artist, you need to set aside only a small area anywhere in your home to be used as an art studio. Ideally, use an inclined drawing table, but any tabletop will do for starters, and add an end table or small cabinet for holding supplies, a flexible light fixture, a chair, and a portfolio for storing paper and finished drawings.

For the greatest comfort and efficiency, a well-designed studio (fig. 38) would be about twelve square feet (four square meters), with natural light entering through large windows that have shades or curtains for regulating the amount of light admitted. If you want to work at night, the best artificial lighting is an overhead fixture with four fluorescent tubes, two each warm and cool light. Add a flexible table lamp with a 100-watt bulb and a floor lamp placed in a corner of the room for ambient lighting. Your drawing table should have a top that can be inclined, or add a tabletop lectern to support a drawing board or pad of paper. Use a good chair on wheels, one that can be adjusted for height. An easel is useful if you want to create quite large drawings, and a taboret, or small cart on wheels, is handy for keeping art supplies nearby. Flat files with large, shallow drawers are ideal for storing loose sheets of drawing paper, large sketchpads, and finished work. Finally, you might add shelves to hold art books and other reference materials, and a sound system to bring musical pleasure to your studio environment.

Fig. 37. A small area in any room of your home can become the setting for practicing drawing. All you need is a drawing board on a table, plus a stool or chair. An easel is useful for large-scale work.
Fig. 38. An ideal studio is equipped with: 1. a desk with tabletop lectern; 2. a taboret, or small chest of drawers on wheels, for supplies; 3. a chair on wheels; 4. an easel; 5. flat files to hold paper and sketchbooks; 6. bookcases; 7. a sound system. And for light: A. a wide picture window; B. ceiling fluorescent lighting; C. desk lamp.

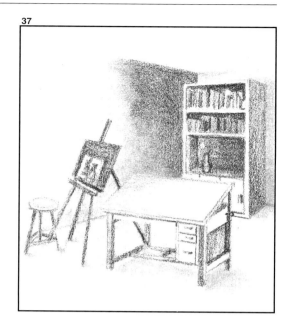

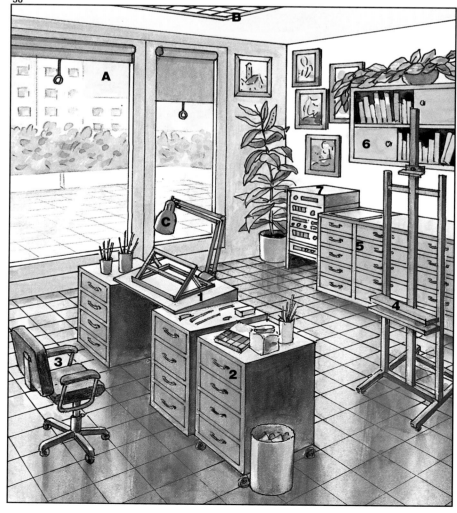

Paper Supports and Drawing Position

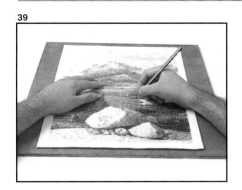

39

40

Figs. 39 and 40. These illustrations show both the wrong (fig. 39) and the right (fig. 40) positions for drawing. The support, or drawing board, should be inclined, so that you may view your work at the correct perspective and more easily catch possible errors.

Fig. 41. If you're right-handed and the source of light is on the right, your own hand will cast a shadow over the drawing.

Fig. 42. Instead, if you want to draw comfortably and accurately, see that the light comes from the left.

Fig. 43. This is the ideal position for drawing; the drawing board, on a slant, rests on the artist's lap.

People often get into the poor habit of drawing on a flat surface. It isn't a good practice, because when your paper is wider or longer than ten inches or so (25 cm), your sight line no longer takes in the whole surface. When your perspective is thrown off in this way, it causes optical errors and then you can't detect mistakes in your drawing. Of course, this doesn't apply to small-scale drawings on paper less than 10 x 10" (25 x 25 cm).

It's best to work on a slanted board either supported on your lap, on the edge of a table, or on the back of a chair. While one hand holds the supporting board, your drawing hand is free to work over the whole composition and to correct small details. I suggest that you use the board-and-table method, which offers the ideal position for drawing.

The support board can be made of 1/4" (2 mm) plywood, or a portfolio may be used as a drawing board, especially when working away from your studio. Also, many art-supply stores sell sturdy, featherweight drawing boards that are perfect for travel. To affix paper to a board, use push pins, thumbtacks, masking tape, or white paper tape.

Another factor to be considered when drawing is the direction of available light. To avoid having your drawing hand project shadows on your paper, if you're right-handed, light should come from your left; if you're left-handed, light should come from the right.

41

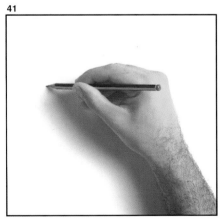

42

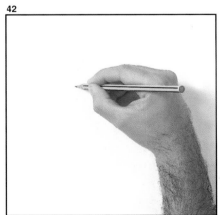

43

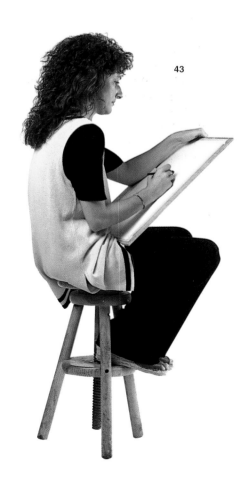

A Range of Drawing Pencils

This page shows a selection of drawing pencils. We'll review how each is used and the tonal values that each produces. It's notable that complex precision drawings can be executed with such relatively simple and easily available art supplies.

The graphite pencil, commonly called lead pencil, is the usual medium for drawing. A solid, black, shiny mineral with a metallic sheen, graphite leaves lines and marks of infinite variety on the surface of paper. The resulting picture depends not only on the skill and personality of the artist, but also very much on the kind of pencil used.

Art-supply stores carry drawing pencils of different qualities and tonal gradations. Pencils are classified by their hardness scale: very fine lines are produced by the hardest lead; thickest by softer pencils. Their codes are printed on each pencil: letter B is the softest grade (from B to 8B); H is for harder pencils (from H to 9H); letters F and HB indicate more neutral gradations. Drawing sticks of pure graphite, not encased in wood, are also sold in forms and sizes designed to create different kinds of lines, and many pencils made for everyday use are also suitable for drawing. Available in a variety of hardnesses, their numbering codes differ from drawing pencils. Ordinary (usually yellow) pencils marked number 1 are equivalent to a 2B drawing pencil; number 2 corresponds to a B; number 3 to an H; number 4 to a 2H.

Artists often use the softest leads because of their more intense gradation, but sometimes it's better to alternate pencils in the same drawing, thus achieving the most beautiful tones from pale gray to a deep, intense black. I suggest that the following pencils are often the most useful for producing successful drawings: 2B (soft lead), for making dark gray tones as well as soft and sinuous lines; 4B and 8B, for rapid sketches (they offer blacker tones than 2B); a regular number 2 writing pencil, for general use and pale grays; and a stick of 4B or 6B graphite, for making wedge-shaped lines and intense grays or blacks.

Fig. 44. From the top, the types of pencils I suggest you stock are: a 6B graphite stick; standard graphite pencils numbered either 3 or H, 2 or B, and 1 or 2B; high-quality pencils numbered 8B, 6B, 4B, 2B, B, and HB; and a water-soluble graphite pencil.

44

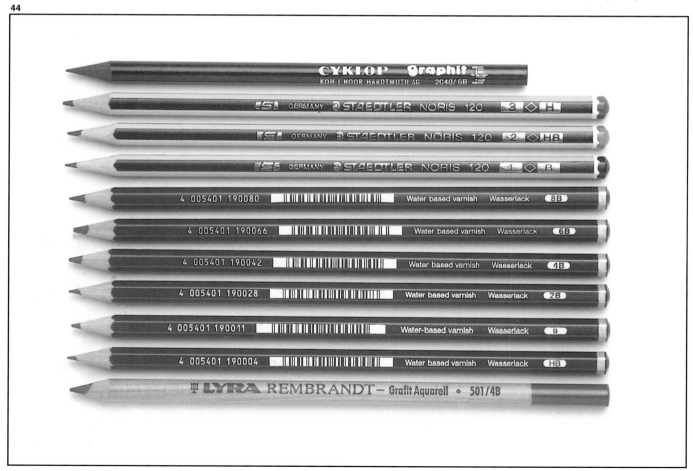

Finally, stumps are cylinders made of paper rolled into tapered ends to use for blending fine lines and marks of all kinds. Stumps of different thicknesses are absolutely necessary for pencil drawing. I suggest that you use one end of the stump for working with light tones and the other for darker tones.

Fig. 45. This chart shows the rich range of gradations made by high-quality pencils, from the intense black 8B to the light gray HB.
Fig. 46. The thickness of drawing pencils varies, depending on the hardness of their graphite. As you'll note, the softer the pencil, the thicker the lead, and vice versa.
Fig. 47. A stick of graphite, available in various degrees of hardness and thickness, is ideal for creating large areas of gray in a drawing. Stumps, in several sizes, are excellent tools for blending graphite, lightening it, and for spreading or applying graphite picked up from another part of a drawing.

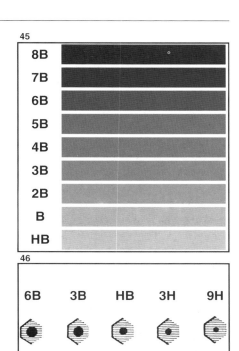

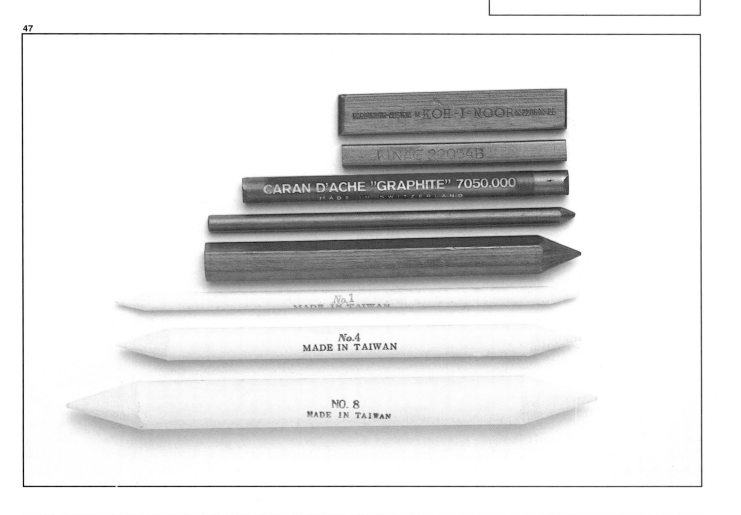

Supplementary Tools

Besides pencils and stumps, there are other supplies that can be very useful in the art of drawing that will make your work proceed with maximum ease.

Referring to the photograph, here are descriptions of the items shown:

A. Wooden board: As a support for your drawing paper, a board is useful both when working indoors and on location.

B. Portfolio: For storing/carrying drawings, it can also be used as a support board.

C. Clips: This type or "bulldog" clips (not shown) are used for securing paper to your drawing board.

D. Fine sandpaper block: Instead of a sharpener, sandpaper is often best for shaping pencils into fine points.

E. Pencil extender: This tool grips a pencil stub so you can use even the shortest remnants, and also holds a graphite stick, protecting fingers from getting dirty.

F. Kneaded erasers: Best for removing graphite, kneaded erasers don't crumble or leave dust, and are self-cleaning if you pull and reshape them as you work.

G. Cutter: For cutting paper, a blade tool can also be used to sharpen pencils.

H. Thumbtacks: When the wood support is soft enough, these can be used to affix paper to it.

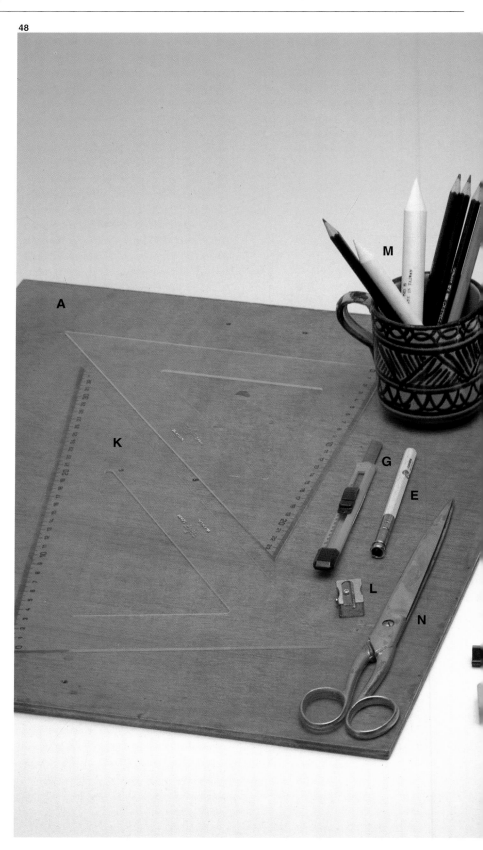

48

Fig. 48. In addition to basic drawing materials, other supplies that are useful to have in your studio are shown in this photograph and described in detail above and on the facing page.

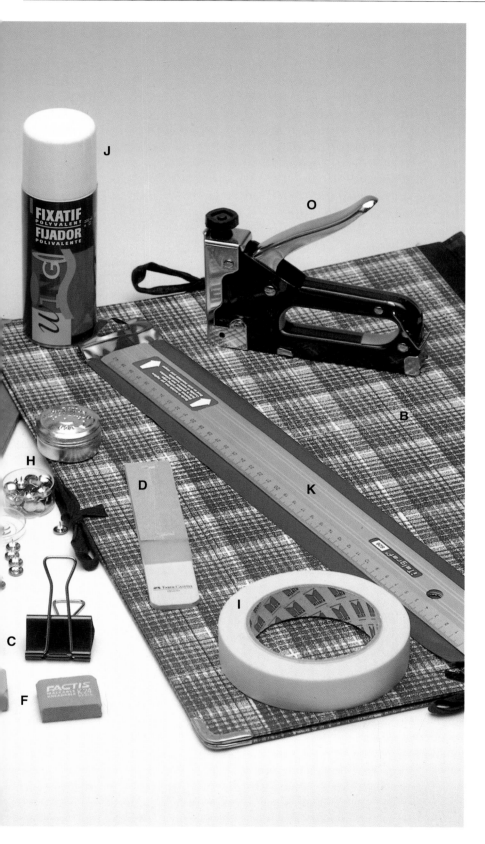

I. Masking tape: For reserving a straight, clean, white border around your paper, this tape can be removed easily when your drawing is completed.

J. Spray fixative: A light mist of varnish sprayed over the surface of a drawing protects it from smudging.

K. Metal ruler, angles: To aid in measuring and cutting paper.

L. Pencil sharpener: A pocket-size metal sharpener is always useful.

M. Mug or jar: To hold sharpened pencils and stumps upright.

N. Scissors: Long blades are best for cutting paper.

O. Staple gun: A very useful tool for stretching paper over a rigid support.

Types of Drawing Paper

When you're ready to begin a drawing, think carefully about the kind of paper you'd like to use. There are many types to choose from, and since your finished drawing will depend in large part on the quality of the paper selected, it's important to be familiar with the properties offered by each.

Drawing papers fall into categories classified by paper grain, or surface texture, ranging from the smoothest to the roughest, or the surface with the most "tooth," the peaks and valleys formed by the paper's fibers. Most high-quality papers offer a different texture on either side. The weight of the paper (calculated by ream) is also a factor to consider; for drawing, 65-lb. paper is a good choice.

A. Smoothest surface: A hot-pressed paper has a "wove" surface and often a satiny finish. Its smooth surface is good for small, detailed, tight drawings made with hard pencils.

B. Fine-grain paper: A cold-pressed, fine-grain paper has a finish with minimum rough texture to it. Grayed areas of pencil marks will distribute fairly evenly, with the grain of the paper being only subtly perceptible. This type paper is suited to work that has both shading and precise details.

C. Medium-grain paper: This cold-pressed paper has more tooth than fine-grain paper, so use it when you want paper texture to show up in your drawing. This surface takes soft pencils quite well; I'd suggest not using harder pencils on it.

D. Newsprint: Newspapers are printed on this flimsy stock; produced in sketchpads for drawing, the paper has a dull, yellowish tone. Because of its low quality and cost, newsprint is generally used for quick sketches and preparatory studies, but some artists produce finished work on it quite successfully, as seen in the drawing on the facing page.

Also note that colored papers (particularly those by Canson) are appropriate for drawings enhanced by white chalk, colored chalk, or colored pencils.

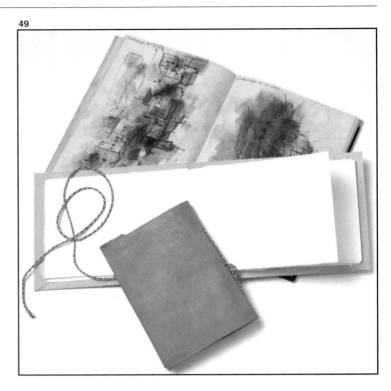

49

Fig. 49. A variety of paper suitable for drawing is widely available. Sheets can be bought separately in various sizes, and a selection of sketchbooks is also offered. For location work, use a sketchbook that has a rigid back cover to support the paper.

POPULAR BRANDS OF DRAWING PAPER AND/OR SKETCHBOOKS

Aquabee
Arches
Bienfang
Canson
Fabriano
Grumbacher
Rising
Rives
Strathmore
Watson-Guptill
Winsor & Newton

Drawing paper is offered in loose sheets, pads, and/or sketchbooks. Popular standard sizes in loose sheets are: 22 x 30" (56 x 76 cm), 30 x 40" (76 x 102 cm), and 38 x 50" (97 x 127 cm). Divide these sheets for smaller drawings.

Sizes for pads and sketchbooks range from 3 x 5" (8 x 13 cm) mini pads to popular 9 x 12" (23 x 31 cm), 11 x 14" (28 x 36 cm), and 18 x 24" (46 x 61 cm) sketchbooks. Drawing pads are bound with glue; sketchbooks are usually spiral-bound.

Newsprint pads range from 9 x 12" (23 x 31 cm) to 24 x 28" (61 x 71 cm).

Paper can also be purchased in rolls of widths ranging from 42" to 52" (107 to 132 cm) and in lengths from 10 yards (11 meters) up to several times that length.

Fig. 52. In this picture by Bibiana Crespo, we can see how the vantage point from which she made her drawing, looking down on her subject matter, affects the perspective and composition of her still life.

50

51

52

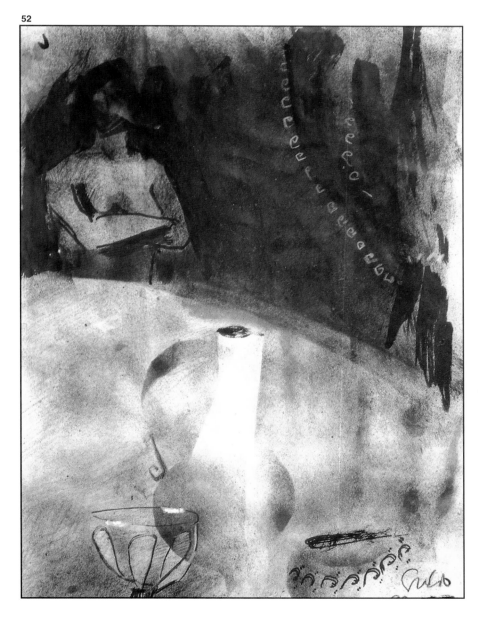

Fig. 50. A smooth, fine-grain paper can receive a full range of contrasts and perfectly even shading. I especially recommend it for portrait drawings.
Fig. 51. Rougher paper offers a coarser texture, or "tooth," so that the grain of the paper is visible in the drawing.

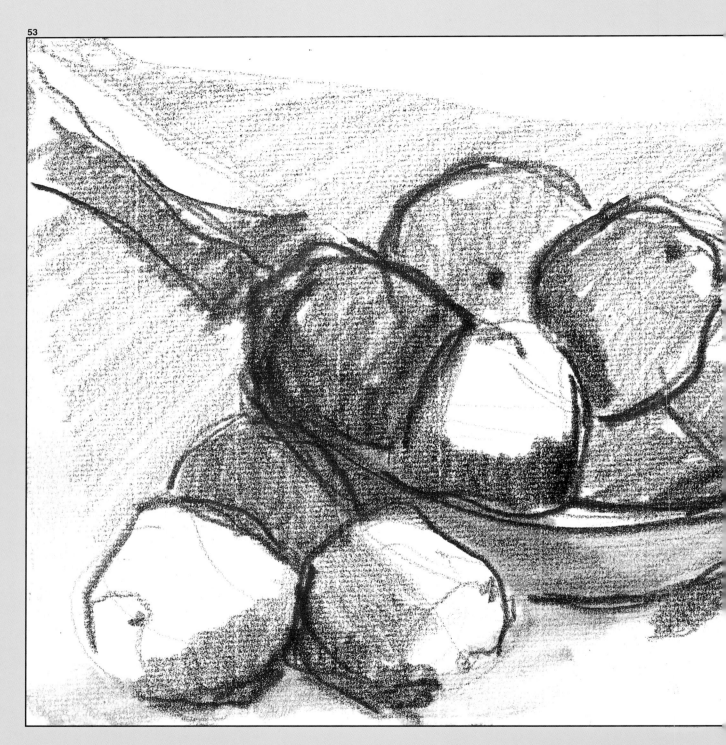

Fig. 53. Simple geometric forms underlie the drawing of this
basic, yet powerful, still life by Bibiana Crespo.

THE FUNDAMENTALS OF ARTISTIC DRAWING

The ability to draw isn't based only on innate talent. Good drawing can be accomplished through a simple and logical learning process. But in order to depict subject matter correctly, you'll need to learn some basic techniques related to scale, composition, shading, and values. This chapter will guide you through those elementary principles in clear terms, enabling you to begin applying them to your own creations right away.

Observing, Measuring, and Comparing

The term *to scale* means proportion or measurement; something drawn "one-third scale" is drawn one-third the size of the original. In preliminary sketches, when working to scale, the basic structure of objects is expressed through simple geometric forms that appear related in size to the model. In this preparatory step, lines are used to reproduce the formal structure of the object, considering both its contours and its proportions. Thus, drawing to scale means representing what we see on a smaller scale, maintaining the differences in size that are found in the model.

Problems with proportion begin when we try to reduce the dimensions of an actual model to the scale of the drawing paper, for we must maintain the same proportional relationships found in reality. Knowing how to establish good relationships between different elements of the subject is the first step to master.

The scale drawing of any subject is based on these factors:

1. Observing and interpreting the model.

2. Finding a basic form or structure that reflects the actual shape of the object that you want to represent.

3. Calculating the proportions and dimensions of the model.

The determining factor for a perfect scale rendering depends on first studying the subject to be drawn, mentally calculating dimensions and proportion of the model.

Although it may not seem so critical an issue, the determination of scale will largely determine the final success of your drawing.

54

Fig. 54. When drawing a house or other structure of this shape, you'll be on the right track if you begin with a simple cube and triangle.

Figs. 55 and 56. If you begin by dividing your drawing paper into four equal sections, you'll be able to distribute and scale the elements within your composition more easily.

55

56

Cézanne's Formula

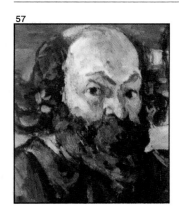

57

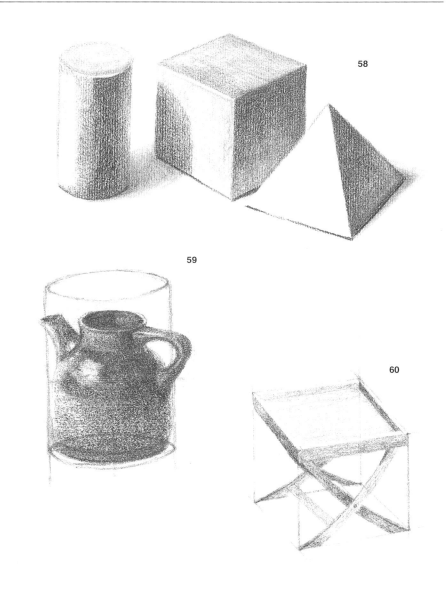

58

59

60

Scaling is the first step to be accomplished on paper, drawing the formal structure of your subject with consideration of its contours and proportions. But before jumping too quickly to drawing, it's useful to review the famous theory about forms set down by the great French artist Paul Cézanne.

In a letter to his friend the painter Émile Bernard, Cézanne wrote that all forms in nature are based on geometric shapes—such as the sphere, the cone, the cylinder—and that by learning to draw these simple shapes, we shall be able to draw or paint whatever we wish, since simple geometric shapes underlie all objects.

Therefore, the scale or structure of an artistic drawing should begin with simple geometric forms. A good exercise before beginning a scale drawing of any object is to practice drawing basic forms in different sizes and proportions. Then, for example, after drawing a cube several times, try transforming it into a concrete shape such as a house, a chair; practice spheres in preparation for drawing an apple, a human head; draw cylinders before trying a jug, a tree, and so on. In terms of the pencil to use, I'd suggest an HB for scale drawings, used lightly so it can be erased and corrected if necessary.

Fig. 57. The theories of nineteenth-century master Paul Cézanne, who is shown here in a self-portrait from the Musée d'Orsay, Paris, provide artists with invaluable guidance.
Figs. 58, 59, 60, and 61. The cylinder, the cube, the cone, and the sphere are forms that underlie the structure of every object. This basic principle, pointed out by Paul Cézanne, guides the drawing of a pitcher, by beginning with a cylinder; a stool, by starting with a cube; and an apple, based on a sphere.

61

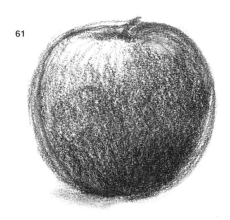

Learning to Scale

As discussed on the previous page, the structure of some objects can be equated to an obvious, closely related geometric form (e.g., a sphere for an apple) in making preliminary scale drawings. But other motifs that have more irregular or complex shapes—

such as human figures, animal anatomy, certain plants—must be handled with more gradual means of scaling.

Scale within a box: Any object, regardless of how irregular and complicated its shape, can be contained within a box. Simply begin by drawing a quadrangular outline that encloses the height and width of the model; here, a bird's head (fig. 62).

Adjust the box; refine drawing: Adjust the box to the outer edges of the bird's head; sectioning the box helps

62

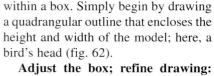

65

66

63

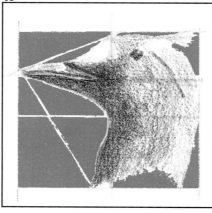
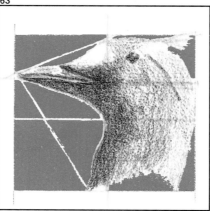
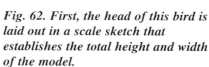

64

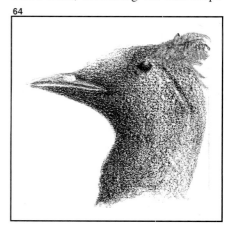

Fig. 62. First, the head of this bird is laid out in a scale sketch that establishes the total height and width of the model.

Fig. 63. Lighter values on the right contrast with darker values under the beak and down the neck of the bird.

Fig. 64. Gradations of grays are blended to smooth the transition from dark to light.

Figs. 65 and 66. Almost all subject matter can be reduced to flat geometric shapes, such as a square or rectangle, to guide initial sketches.

guide proportions. Using long contour lines, refine the shape of the bird's head. Begin shading (fig. 63).

Scale with shadows: When a model offers sharp contrasts of light and dark, the edges of shadows can be a useful reference for scaling. Draw broad areas of light and dark, without attention to details. Begin with soft shading; as the drawing progresses, shading will intensify until definitive values are achieved (fig. 64).

Scale with a grid: The grid indicated above (fig. 63) is especially useful when your reference is a photo or print that differs in size from your drawing. By dividing both photo and drawing paper into squares, a system of common coordinates will enable you to scale your model more easily.

Aligning Points

The method of using aligned points is an efficient way to study the proportions of objects you wish to draw. By finding points of reference, both horizontal and vertical, you'll have a clearer picture of the structure and contour of objects and the distances, or negative spaces, between and around them. Take a few minutes before beginning to draw to observe your subject matter carefully to get a feeling for each form; study spaces between objects as well. It's basically a matter of comparing and determining relationships between objects. In the still life below, for example, what's the size ratio of the small pitcher to the height of the bottle? How does the pitcher's size relate to the size of the apple?

The structure of objects can be understood by measuring and constantly comparing their heights and widths. Imagine vertical and horizontal lines that connect basic points between objects. One measuring device is to hold a pencil in a vertical position, at arm's length and positioned at eye level. With one eye closed, using the pencil as a measuring tool, you can calculate the relationship between objects.

Figs. 67, 68, 69, and 70. Analyzing the relationship of proportions within this still life, note that the total width of the arrangement is approximately equal to the height of the bottle (fig. 67) and the width of the cup is two-thirds the width of the pitcher (fig. 68). If we draw an imaginary line from the fruit in the foreground to the lip of the cup, we find that both elements are about the same height. In the same way, if we project a diagonal from the top of the bottle to the fruit in the foreground, the pitcher and fruit are found to be aligned (fig. 69). There are also equal measurements that are repeated: the widths of the bottle, the cup, the lip of the pitcher, and the fruit (fig. 70).

67

68

69

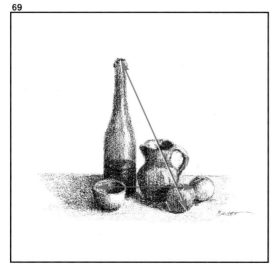

70

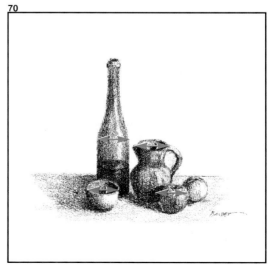

Paper Format

The final look of a picture depends on several factors. The first consideration is the format of the paper chosen. Will it be horizontal, vertical, square, or, more rarely, circular? Once format is determined, the distribution of all elements over the surface of the paper, the framing of those elements, and other factors come into the picture, as discussed on the following pages.

The format of paper chosen for a drawing can predetermine its composition and in large measure contribute to the picture's success. Learning to choose the shape and position of the paper is basic. Here are some guidelines to help you select.

Horizontal format: When paper is oriented horizontally, wider than it is long, the gaze of the viewer tends to move from one side to the other over its surface, usually from left to right. Because a horizontal format permits a greater depth of field, this is the preferred format for landscapes, cityscapes, seaside, harbor scenes, and other open spaces being depicted.

Vertical format: When paper is oriented vertically, the viewer's gaze travels over the picture surface from top to bottom. Because a vertical format tends to bring objects closer to the viewer, it it usually preferred for portraying the human figure, portraits, and subject matter that the artist wishes to keep at close range.

Square format: The most neutral format, a square sheet of paper usually directs the viewer's eye to the center of a composition.

Circular format: In spite of being the most natural of formats, since the circle more closely corresponds to our field of vision, a round or oval sheet of paper is the most difficult on which to create a well-balanced drawing.

Fig. 71. As this work by Albrecht Dürer illustrates, the vertical format is best suited to portrait drawings.
Fig. 72. During the eighteenth century, cameo formats were popular, as in this self-portrait by French artist Maurice-Quentin de Latour.
Fig. 73. A wide horizontal format is ideal for a landscape with lots of depth.

71

73
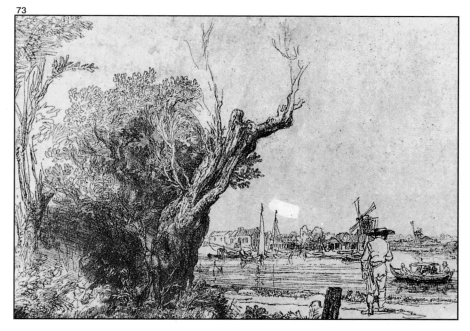

72
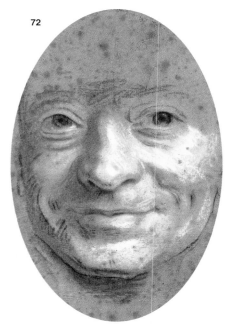

Composition

After considering a suitable format, the next step is studying ways to organize space well within your drawing. Composition is the way in which shapes are organized on a picture plane so that its subject matter makes sense to the viewer. In other words, the role of composition is to create a coherent image.

The art of composition means combining and organizing all the elements of your subject matter with a sense of order and unity. But how can many disparate objects be combined in order to achieve a visually satisfactory ensemble? There is no set rule for correct composition, but there are some guidelines that can be very useful.

One, sometimes called Plato's rule, can be summarized in one sentence: "Find and represent variety within unity." Beginning with shapes, their sizes, and placement, one must organize pictorial elements so that variety is presented as a compositional whole that will awaken the interest of the viewer. Three illustrations of this principle (figs. 74, 75, 76) show just a

few of an infinite range of pleasing compositions that can be found when setting up a still life featuring fruit.

Another guiding principle is Euclid's "golden section." In order to establish the point where the principal element of a composition should be located, Euclid said:

"So that the space divided into unequal areas be aesthetically pleasing, one must establish the same relationship between the smallest part and the largest part, as exists between the largest part and the whole." Thus, if we would place the main element in the center of a picture, to avoid monotony and symmetry, the rule of the golden section allows us to simply move "the center" to one side or another.

Fig. 74, 75, and 76. Comparing the composition of these three still lifes, the arrangement in the first (fig. 74) lacks cohesion because the objects are too scattered. Although objects attract our attention individually, they do not gel as an ensemble. Conversely, too much massing of objects (fig. 75) produces an uninteresting, monotonous grouping. Now see how the same objects achieve variety within unity (fig. 76) in a composition that is casual and realistic yet well balanced and visually very satisfying.

74

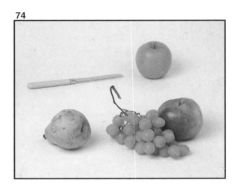

75

77a

Figs. 77a, 77b, and 77c. If you study the ratio of the blue rectangle to the yellow (fig. 77a), you'll see that the same relationship exists between them as between the largest part and the whole. This "golden section" principle is further illustrated by the vertical division (fig. 77b), then applied to the drawing (fig. 77c), where the resulting off-center focal point is shown to be visually effective.

77b

77c

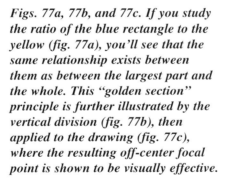

76

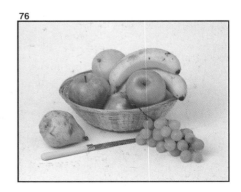

Vantage Point

Figs. 78 and 79. The vantage point from which you view subject matter directly affects how it will be composed in your drawing. The same arrangement of fruit seen from an elevated position (fig. 78) versus at eye level (fig.79) illustrates the differences in cast shadows, shapes of the fruit, and the absence or presence of a horizon line, which in this case, is the far edge of the table.

78

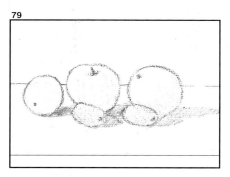

79

The way we perceive a still life, landscape, or figure drawing is directly dependent upon our vantage point; that is, where we stand or sit in relation to the subject, an important factor to consider when composing a drawing.

Looking at two sketches of the same fruit, note that in the first (fig. 78), the objects within the composition have been drawn without a line to indicate the tabletop (the horizon line), suggesting that the grouping was observed from an elevated position, that the artist was standing.

The second version (fig. 79) does show a horizon line, which immediately lets us know that the artist's vantage point was from a lower position. If you sit down, of course, the line of the edge of the table will move down with you, and the elements of the still life will be seen from a more level position. Note also that the shapes of the fruit and the shadows they cast differ in the two examples. Seen from a higher position, the objects are more rounded; when the viewer stoops, the shadows lengthen and seem closer to the horizon line.

To summarize the importance of vantage point, remember that whenever you get ready to draw something, look at it from a few different positions before deciding where you'd like to set up your drawing board or position yourself and your drawing pad for the work at hand. I'd suggest that you not settle for the first one that looks good. Vary your position in relation to your subject matter until you hit upon the very best vantage point for it.

Figs. 80 and 81. Examples drawn by Bibiana Crespo show a basket of fruit drawn from a standing position (fig. 80) and from a seated position (fig. 81).

80

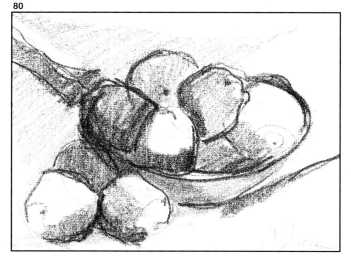

81

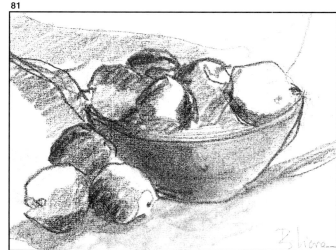

Composition Layouts

Once you've selected your subject matter, paper format, and best vantage point, now it's time to organize a composition on your drawing surface. The simplest division is to draw a straight line across the paper to indicate the horizon, or a vertical one to divide the space through the center. While some artists stick with this basic method, I think it can result in monotonous, uninteresting compositions. So I suggest that you use a combination of various geometric plans that create a more lively framework for your composition.

For hundreds of years, artists have used certain predetermined configurations to guide the placement of elements in composing drawings and paintings. Renaissance compositions were often triangular in layout, a very popular style because its symmetry gave ascendance to the central, featured figure. Later, during the Baroque period, artists used diagonals, resulting in animated, asymmetrical compositions. Two more examples of geometrically planned compositions are also shown on this page.

Most people are drawn to layouts based on geometry because of their concrete configurations, but I encourage you not to settle on just a single form. By using several, the body of your work will present a broader visual ensemble. On the other hand, avoid the extreme of being overly ambitious and including too great a variety of forms in a single composition, which could confuse viewers.

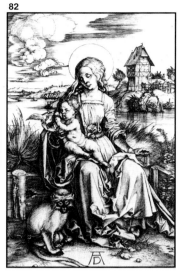

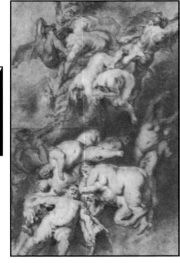

Fig. 82. The triangle was often used as a basis for composition during the Renaissance, as this print by Albrecht Dürer clearly illustrates.

Fig. 83. Examining this work by Peter Paul Rubens reveals an imaginary line that crosses the picture plane from the upper left to the lower right. Compositions based on diagonals were often used during the Baroque period.

Figs. 84 and 85. Geometric shapes underlying these two compositions are a parabola (fig. 84) in Merche Gaspar's drawing of a nude, and an oval (fig. 85) in Francisco Bayeu's still life.

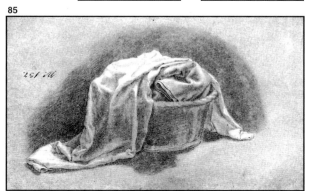

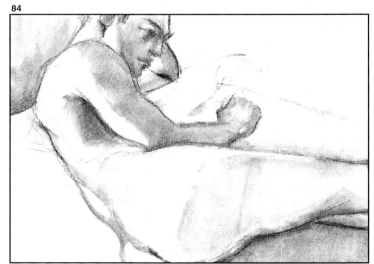

The Third Dimension

Now that we've briefly examined generalities governing composition on a flat surface, let's add depth—the illusion of a third dimension that enlivens a drawing by giving volume to objects and creating a sense of receding space.

Here are some broad generalities governing the portrayal of depth.

1. A clearly defined foreground: If you place an object of familiar size (like a tree or car) in the foreground, you'll enable the viewer to compare the scale of that object with those in more distant areas. The viewer then unconsciously establishes the distance between near and far objects, thus reading depth into the drawing.

2. Superimposing successive planes: With this method, the third dimension is suggested by drawing successive planes in the manner of theater curtains, one behind another, then another, accentuating the effects of depth.

3. Perspectival effects: Besides being one of the most often used formulas for creating depth in drawings, perspective is one of the most effective. Choosing a point of view and layout beforehand enables you to create the depth effects.

4. Contrast and atmosphere: The sense of distance produced by atmospheric changes can be expressed by progressive bleaching of tonal value when drawing landscape, like a delicate mist that envelops successive planes as they move farther into the distance.

Fig. 86. This fully developed drawing shows us rich tonal contrasts established in the foreground contrasted against successively lighter, less-defined elements in the middle ground and background. The gradual change reflects the basic principle of employing atmospheric perspective to bring depth and distance to a drawing.

86

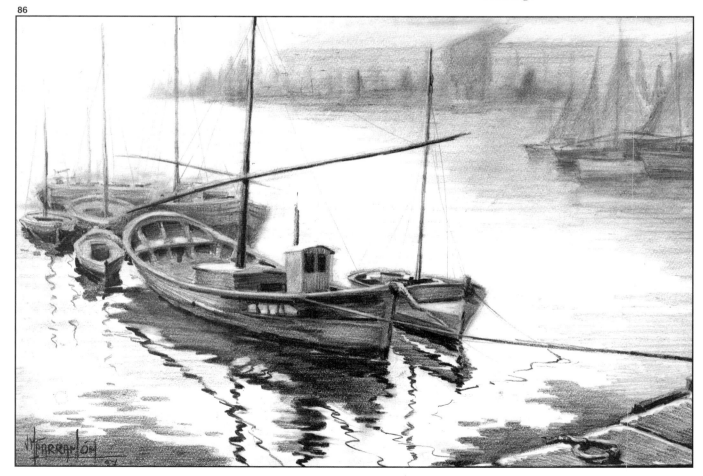

Viewfinder

How much of that large vista that you see should you include in your landscape drawing? For your still life, should you draw all or just some of those many items displayed on your table? To help you decide the boundaries of your composition—what to include, what to omit—a viewfinder can be very useful. For a do-it-yourself viewfinder (fig. 88), simply cut a piece of cardboard into two L-shaped strips, then move them around on your reference photo or print (fig. 89) until you find the composition that appeals to you.

When drawing on location (fig. 89), use your viewfinder to frame the view in front of you, then select the area you wish to draw. Close one eye and move the frame backward and forward; you'll see that the closer the frame is to you, the larger your field of vision; farther from you, your field of vision reduces through the frame. Pick the layout that you like and make a quick pencil sketch so you can analyze your chosen composition.

Viewfinders can also be used to analyze and extract motifs from your own sketches. Just take a preliminary sketch and place a viewfinder around it. Now you can see what it would look like in a horizontal or vertical format, or you can extract details that might be useful for other, more finished works.

As you can see, viewfinders are immensely helpful. By making use of them, you will surely make your compositions more original, so I'd suggest that you keep them at hand and use them often.

87

Fig. 87. To make a viewfinder, all you need to do is cut a piece of mat board or simple cardboard into two L-shaped strips.

Fig. 88. Once you have a viewfinder, you can experiment with different layouts based on your own sketches or earlier works.
Fig. 89. Using a viewfinder will help you select the most interesting focus on a subject. It gives you a chance to study various compositional layouts—what to include and what to exclude—before you begin drawing.

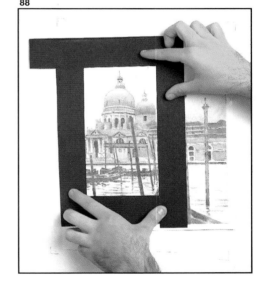

88

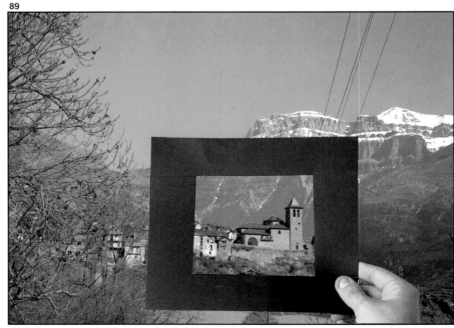

89

Light Direction

90

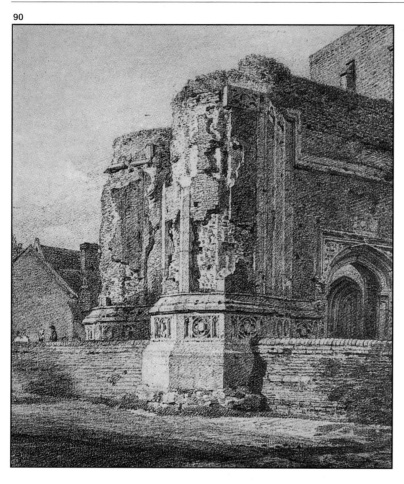

Fig. 90. The English artist John Constable, in this careful drawing of East Bergholt Church (1817), captured the way in which light and shadow transform the ruins as they play over the raised surfaces and crevices of the structure.

Fig. 91. Frontal light illuminates this sculpted head without producing shadows.

Figs. 92a and 92b. When light comes from the side, the object projects distinct shadows.

There are general principles that determine the effect that light produces on objects and, consequently, the quality of the resulting shadows. The first of these is the direction of light.

Shadow plays an important role in giving objects a sense of volume. Note that I'm talking about shadow, not light.

Although light is the cause of shadow, the pencil artist is usually working in the reverse, darkening the white surface of the paper with graphite, using the varied range of grays, the technique known as chiaroscuro (Italian for light-dark).

In a beautifully shaded drawing such as the one by John Constable on this page, you can appreciate areas of light, areas of dark, and a varied range of grays that combine to create a forceful impression of volume.

Representing forms and volumes correctly requires a mastery of tonal gradation.

If you study this and other fine drawings in which shadows are obvious, you'll see that the more shadow there is, the stronger will be the sense of volume projected.

Light can fall on a subject in many possible ways, each causing a different effect, as shown on the sculpted heads illustrated here.

Frontal light: When light falls on a subject from the front, it produces

91

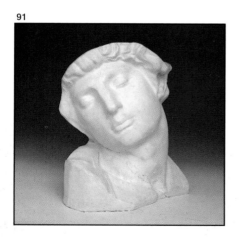

92a

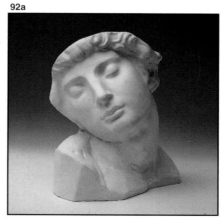

92b

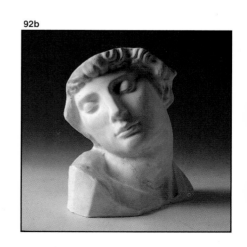

almost no shadows; therefore, it's not the lighting to use if you want to create strong shadows.

Frontal-lateral light and lateral light: Illuminating a subject from one side, projecting shadows on the opposite side, produces the greatest contrast between light and shadow.

The distance between the source of light and the subject is important; the farther away the source, the longer the shadow, and vice versa.

Overhead light: Light originating above the subject, generally from a skylight or high window, offers a soft glow for painting or drawing. Even though the shadows are not so striking, they are short when cast by overhead light and when the light source is directly above the model, there are no shadows.

Light from below: Not too usual, but a source of light below the position of the model can be very dramatic, lending an air of mystery to a subject.

Back light: Falling on the model from behind, this light casts the front, which the artist is looking at, into shadow.

Before trying to depict light and shadow falling on objects, you should become familiar with all of the possibilities offered by graphite pencil, simply by practicing gradations.

If you use pencils of different hardness to create strips of a series of

93
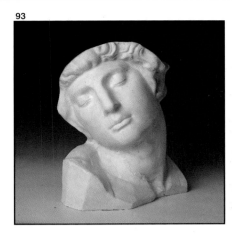

Fig. 93. When the source of light is above the model, it creates very short shadows.
Fig. 94. Of all the possibilities, light cast from below is the most unusual; it gives the model a disturbing, eerie feeling.
Fig. 95. When the light source is from the rear, it puts the front of the object in deep shadow.

94
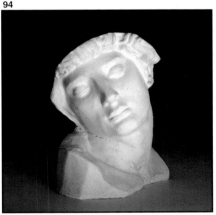

95

grays, from the very lightest to an intense black, this tonal-gradation exercise will be very useful for capturing a wide range of shadows.

Mastery of chiaroscuro is integral to fine drawing. After scaling a drawing, tonal modulation gives it its greatest

expression, the triumph of form, the truly artistic completion of a work. Shading gives your drawings depth and light and defines space and the volume of the subject represented.

Fig. 96. Practicing tonal gradations will familiarize you with the full range of values offered by your materials.

Quality and Quantity of Light

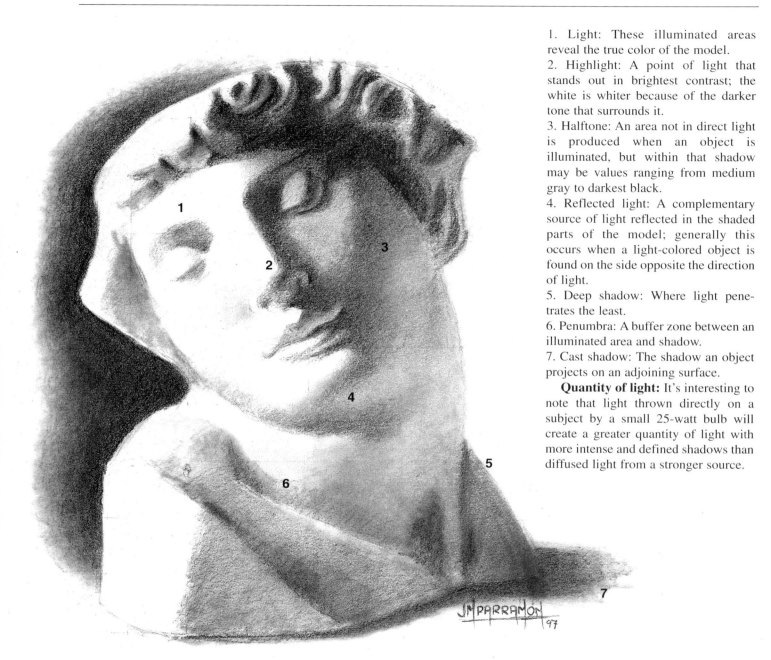

1. Light: These illuminated areas reveal the true color of the model.

2. Highlight: A point of light that stands out in brightest contrast; the white is whiter because of the darker tone that surrounds it.

3. Halftone: An area not in direct light is produced when an object is illuminated, but within that shadow may be values ranging from medium gray to darkest black.

4. Reflected light: A complementary source of light reflected in the shaded parts of the model; generally this occurs when a light-colored object is found on the side opposite the direction of light.

5. Deep shadow: Where light penetrates the least.

6. Penumbra: A buffer zone between an illuminated area and shadow.

7. Cast shadow: The shadow an object projects on an adjoining surface.

Quantity of light: It's interesting to note that light thrown directly on a subject by a small 25-watt bulb will create a greater quantity of light with more intense and defined shadows than diffused light from a stronger source.

Other factors that allow the artist to interpret shadow on a subject are the quality and quantity of light cast on the subject.

Quality of light: Another aspect of light is whether it is direct or diffused.

Direct light refers to natural or artificial light that falls directly on a subject, causing deep, well-defined shadows.

Diffused light can be compared to the light outdoors on a day when the sun is hidden behind clouds, creating less-defined shadows with soft edges.

Finally, let's identify the variety of light and shading effects that can be found on the head shown in the drawing on this page:

Line Direction

In quick sketches, the direction of a design is contingent upon the lines used to give a particular texture to a drawing. But, how does one know what direction those lines should take?

Here's a general rule that I offer for guidance: As far as possible, the direction of your pencil lines should wrap around, or follow and explain, the volume of your subject. Although the usual direction of drawing lines is on a slant, many variations are possible. If you're drawing the flat surface of a table, for instance, the direction of your pencil strokes should be straight; on the curved surface of a tree trunk, your pencil marks should be curved. This means that the choice of line depends in great part on the form, structure, and texture of the subject you depict.

For parts of the human body, cylindrical forms suggest the use of curved lines; a grouping of fruit suggests circular marks; the sea, horizontal strokes; plants and flowers, undulating lines. Careful consideration of the types of lines used is equally helpful in drawing landscapes, figure studies, portraits, or still lifes. The choice of the right line will add much to the sense of volume in your drawing, so it bears repeating: The orientation of lines should usually follow the shape of the object being drawn.

Figs. 97 and 98. These drawings by Merche Gaspar offer examples of the variety of strokes that can be used in a single drawing: undulating lines, curling lines, circular slanted lines, and circular strokes.

97

98

99

100

Fig. 99. When drawing hair, pencil lines should follow the natural direction in which the hair grows and falls.
Fig. 100. The best pencil strokes for suggesting skin tone and texture are curved lines, which also lend a sense of volume.

Tonal Value

Allocating values completes the drawing that you began with composition and scale, giving the work a truly artistic finish.

To designate values, you must resolve the effects of light and shadow through the use of different tonalities. When you observe the subject in natural colors that you're going to draw in pencil, you must imagine that colorful subject in black and white—which is to say, in the range from black to white that your lead pencil is capable of producing.

The task requires considering and comparing tones and shades to decide which are darkest, which are lightest, and which represent the many values that fall between.

There is some methodology that will help you with those classifications. Here are three steps to guide you.

1. Draw light, not outlines: The usual way to draw an object is to outline its shape. But if you glance around you for a moment, you'll see that the form of an object is not limited to its outline. Form and the way we should depict it in a pencil drawing has all to do with how light and shadow are modeled and arranged on an object's surface.

With this observation as a good way to start, study the effect produced by light on the object (let's consider shadow as an effect that derives from light, for a shadow is really only the absence of light) and begin your drawing without lines, portraying all edges and contours by tone.

2. Allocate values: The success of this process depends not on hard contrasts between lights and shadows, but on progressive toning. To establish a resemblance to the object, gradually and simultaneously relate forms and values, according to the intensity of light the object receives.

Don't begin by constructing and shading the head completely, then going on to another part of the body. The way to proceed is quite the contrary. The correct procedure is to

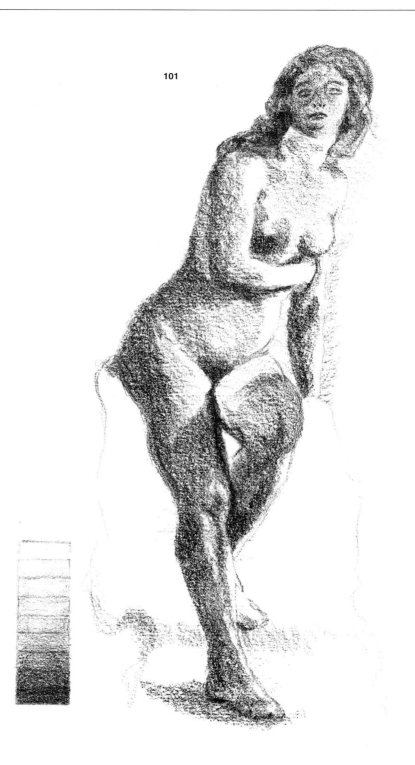

101

Fig. 101. Light creates a range of tones, or values, on objects, from absolute black to white. A range of values is indispensable in giving a third dimension to forms in a drawing.

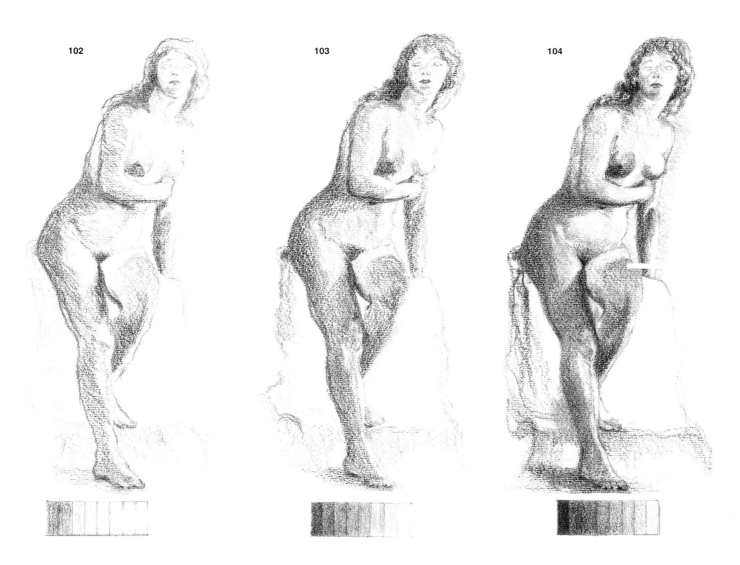

work on the drawing as a whole, progressively, so that all parts of your picture advance at the same time. Shadows must be distributed faithfully, with the various shades that the model presents adjusted from a light scale of grays, continuing with intermediate tones, and ending with a range of more intense values.

3. Squint: The standard way to see value allocation is by looking at an object with half-closed eyes. This is a tried-and-true method that will serve you well whenever you draw still life, figures, or landscape.

Whether your subject matter is a simple jar and two pieces of fruit on a table in front of you, a seated model posing for you, or a sprawling vista that takes in everything from mountains in the distance, to a river in the middle ground, to a meadow of flowers in the foreground, squint when you study it. Squinting suppresses the middle tones and small details, so that only the most striking tones are distinguished.

In the exercise on this and the facing page, observe the progression of values from slightly darkened to ever-increasing contrasts.

Figs. 102, 103, and 104. In developing a drawing, values are resolved from less to more, beginning with a light scale of tones and progressively intensifying them until the modeling of the drawing is completed.

Contrast and Atmosphere

Once you've drawn a subject in two dimensions, you can darken or lighten certain areas or points to create contrasts that better describe the effects of depth and distance. The representation of the third dimension through the effects of light and shadow creates contrast and atmosphere. You should try to reproduce that sense of atmosphere in your drawings.

Sometimes it's a matter of forcing contrast, actually creating false contrasts that cannot be seen in the model, as Leonardo da Vinci advised when he said: "The background around a figure should be dark where the figure is illuminated and light where it is in shadow."

Creating strong contrasts will define contours, separate shapes, and suggest form. When we see an object from up close, our eyes focus on it and everything around it that is not at the same distance falls out of focus. When you draw a still life, for example, you should try to produce the same look, drawing the objects in the foreground in detail and leaving the objects farther back less well defined.

This effect of atmosphere is most obvious in a landscape drawing that

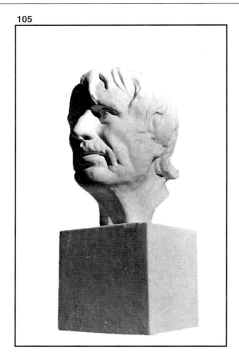

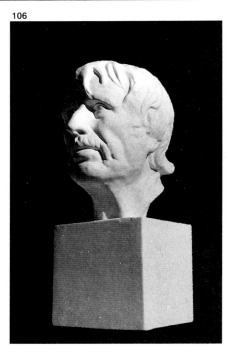

Figs. 105 and 106. The law of simultaneous contrast means that white is whiter when tones near it are darker; gray is more intense when adjacent grays are lighter. This optical illusion can best be seen by

comparing these two sculpted heads. The one with a white background seems to contain more intense grays; with a black background, lighter grays, but the two are identical, except for their backgrounds.

Fig. 107. The same principle of darkening background values can be used to highlight certain areas of a drawing more than others. Here, Merche Gaspar has intensified part of the background to focus primary attention on the baby's head, and applied less intense grays around the white dress to define it more clearly, while retaining primary focus on the face.

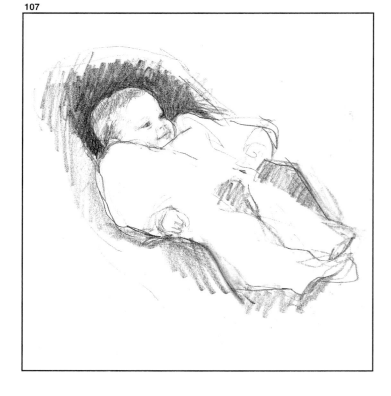

tries to give the effect of distance in the background. With landscape, the sense of distance is actually created by the atmosphere interposed between the viewer and the distance. The challenge is to re-create that effect in your drawing.

The best time to observe the phenomenon produced by atmosphere is in the early morning, when a soft mantle of fog just allows a glimpse of the barely risen sun. These light veils interposed between forms create the effects of the distance between the vivid tones and more sharply delineated and contrasted form of the foreground and the blanched, hazy forms in the background.

To summarize the factors that you should take into account regarding contrast and atmosphere when you are drawing a landscape:

1. The foreground should always be brighter and more contrasted than the distance.

2. As objects move back into space, their colors bleach out, with a tendency to gray. Therefore, objects in the distant background should be represented with a certain lack of clarity.

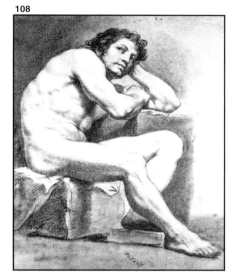

108

Fig. 108. In this academic study, artist Francisco Bayeu has darkened the background to heighten tonal contrast between the figure and its setting.

109

Fig. 109. A sense of distance in a scene such as this can only be achieved by applying darkest values in foreground areas, and gradually lightening values, with palest tones reserved for the farthest, more distant area on the horizon line.

Rough and Preparatory Sketches

Sketches and preparatory studies are used to make quick observations and to evoke spontaneity, imagination, and originality. There are several basic uses for this kind of drawing.

First, sketches help us to understand drawing as an experimental process in which we may discover meaningful and aesthetically pleasing images. The preliminary drawing is also our first

110

111

Figs. 110, 111, and 112. People and pets make ideal subjects for rapid sketching from life. Find or make opportunities to draw your friends, relatives, and even strangers you see in the park, on a train, in a coffee shop, etc. Cats, dogs, birds, fish, squirrels also offer an endless source of subject matter for quick sketches.

representation of various elements of an object, providing an opportunity to analyze its structure. And making rough and preparatory sketches is also a good way to perfect the practice of drawing.

The rough sketch should be spontaneous, fresh, and experimental, an end in itself. Preparatory drawings, on the other hand, are used in the planning of more finished works such as paintings or sculptures. In the latter case, the artist can create a whole series of experimental drawings to be used as reference in working out a final composition.

In terms of the pencil to use for rough sketches, I'd suggest a soft pencil, at least a 4B, which produces a

112

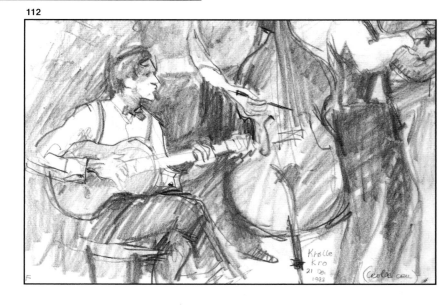

113

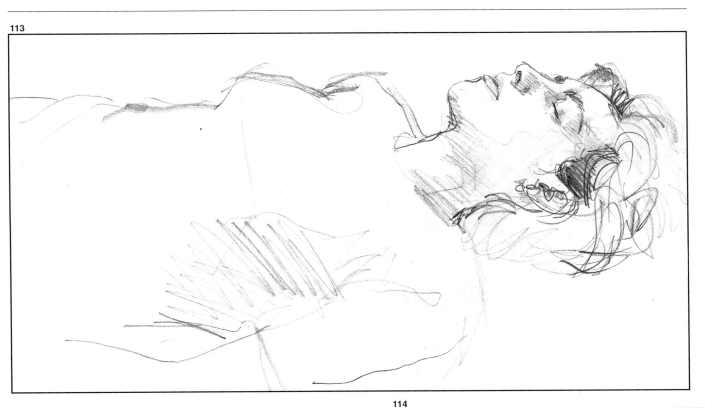

definite line and handles easily for making quick sketches. A soft pencil enables you to create lines that are fine or broad, and to use varied strokes: strong, wide, short, long, undulating, energetic, superimposed, and blurred. Soft pencils also respond well to changes of direction in the orientation of your lines, from ascending to descending and the other way around.

The selection of subject matter for sketching is unlimited. Draw anything that you find interesting: figures, faces, animals, landscapes, plants, boats, buildings, and don't overlook mundane objects that are all around you, such as your shoes, a pile of books, kitchen utensils, a cup and saucer, and so on.

Any location is fine for sketching. Take a sketchpad with you everywhere and practice in the park, at the zoo, at the beach, on a bus, during a coffee break at work, during intermission at theater or while waiting for a concert or movie to start. Have the urge to create and the daring to practice anywhere. One thing is certain: To become good at drawing, you must practice as often as possible.

Figs. 113 and 114. As your sketching skills improve, you'll eventually want to draw more developed portraits. Drawing figures not only requires working out correct anatomical proportions, but also suggesting a facial resemblance to the model.

114

STEP-BY-STEP EXERCISES

On the following pages, you'll find a series of practical exercises in which to apply the various principles and techniques presented in earlier parts of this book. With the help of text and illustrations that clearly describe each step, you'll be able to understand and use the broad variety of exercises conceived for practicing pencil drawing. Although the results may not always be exactly what you want, the practice of each and every exercise is absolutely necessary for attaining ease in this medium. Use the pages of ruled guides that are included at the back of this book, and don't worry about repeating exercises; that's what practice learning is all about.

Basic Pencil Strokes

In the following exercise, I invite you to get to know, through hands-on practice, the most common strokes used in artistic drawing. Mastering these basic strokes will help you toward success in all of your future drawings.

With an objective of creating a drawing using a rich variety of pencil strokes, you must not only train the movement of your hand, but also know the various ways to hold your pencil and control the pressure you apply on it. There are three basic ways to hold a pencil:

Writing position: The grip is just as if you were writing (fig. 115), but hold the shaft of the pencil a bit farther up, so that your hand is more mobile. This position is useful for working on details and for drawing continuous lines without having to lift the pencil from the surface of the paper.

Pencil shaft in the palm: This is the way artists generally hold the pencil (fig. 116), enclosing its shaft in the palm. This position is especially suited to working on a relatively large scale and when creating wide areas of tonal gradation.

Shaft held horizontally: In this position the shaft is held horizontally (fig. 117), an appropriate method for small drawings because it allows for very light pressure on the paper and thus more control of the intensity of the line .

As you'll discover, the density of a pencil line depends on the pressure applied, the hardness of the pencil, and the position in which the pencil is held relative to the paper. When you hold your pencil with the shaft within your palm, the pencil is on a 30-degree slant and the graphite point will leave a wider mark. If you hold the pencil in a writing position, the slant will be 45 degrees, so the resulting line will be the width of the lead itself. Remember that the hardness of a pencil also determines the intensity of its stroke: delicate when a hard lead is used; thicker and more intense when softer lead is used.

Now let's look at some examples of basic strokes and gradations made with 2B and 6B pencils on paper with a medium tooth, or grain. I encourage you to take the first sheet from the back of the book and follow the instructions below, which will help you to complete the exercise successfully.

Figs. 115, 116, and 117. Three basic ways to hold your drawing pencil: for most line work, in the writing position, with the shaft resting between thumb and index finger; a looser hold for toning broad areas; most flexible position for regulating the pencil pressure on your drawing paper.

115

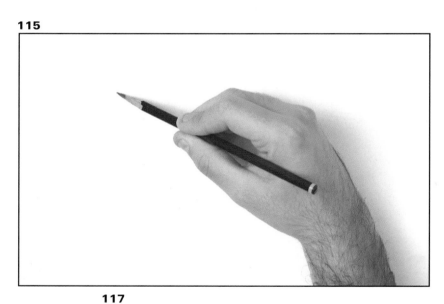

116

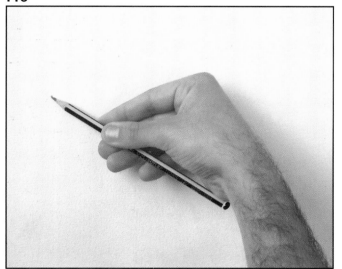

117

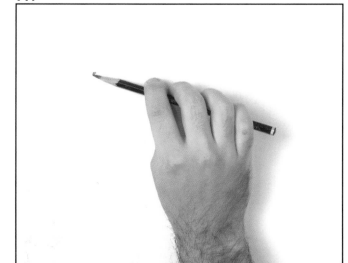

You'll see that sheet number 1 is divided into ten sections to make the exercise easier. In each section, numbered from 1 to 10, you'll be able to fill in one of the exercises that follows:

1. Drawing fine lines: Begin by holding your 6B pencil in a writing position. With the pencil tip slanted, sketch a series of fine, short lines (fig. 118). Make one row lines that run vertically, one row on a diagonal, one horizontally.

2. Drawing thick lines: For the second exercise, hold the pencil horizontally, so that the wider point creates wider lines. Draw a series of continuous vertical marks, trying to keep the distance between the lines the same (fig. 119).

3. Practicing diagonals, verticals, and horizontals: Put aside for a moment the number 6B pencil that you used for the exercises above and pick up the 2B pencil instead. Now draw closely packed groups of diagonal, vertical, and horizontal lines, following the order indicated in the illustration (fig. 120). This exercise will help you master drawing lines of a certain length, a skill that is useful in the drawing of form.

4. Drawing curls: Hold your pencil in a writing position but on a slight slant, and draw continuous curls or loops until the area is filled. Try hard to use a continuous line from one curl to the next. Practice this pencil stroke as often as possible because it's one of the most frequently used in artistic drawing (fig. 121).

5. Tonal gradation with circles: Take your 6B pencil again and, returning to what you learned in the previous exercise, practice a horizontal gradation with continuous little loops (fig. 122). Try to achieve a perfect gradation with the successive overlapping of the circles.

Figs. 118, 119, 120, 121, and 122. Here's a sampling of some of the most useful pencil strokes that you'll need to bring vitality and variety to your drawings. When shading large areas, particularly broad expanses of background, experiment with a few of these techniques to see which is most effective in a particular drawing.

118

119

120

121

122

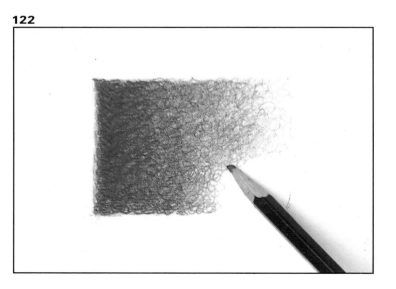

6. Drawing loops: With your 6B pencil held slightly slanted, try to draw a series of loops without lifting your pencil from the paper (fig. 123). Just support the pencil point and move it in a circular motion, almost creating a spiral effect.

7. Drawing circles: Draw a group of circles of similar size without lifting your pencil point from the paper (fig. 124). Try to make the circles as perfectly formed as possible, keeping them close together, even overlapping here and there.

8. Gray gradations: Holding the pencil in a writing position, alternate pressure on the point between hard and soft to achieve a gradation from strong and vigorous to soft and delicate (fig. 125).

9. Continual line: Using your 2B pencil, practice drawing a long, horizontal, continuous line (fig. 126), going back and forth, without lifting the point from the paper, and keeping the pressure more or less consistent.

10. Blending with fingers: Draw a tonal gradation and then rub the graphite with your fingers (fig. 127). Rubbing with your finger gives you greater control of the range of tonalities than can be obtained by using a stump.

Figs. 123, 124, 125, 126, 127. Practicing various strokes and mastering blending techniques will enable you to take advantage of the great range of artistic possibilities offered by the pencil medium. For blending, instead of using a stump, some artists prefer rubbing graphite marks with their fingers to pull lines together into a continuous gradation.

123

124

125

126

127

128

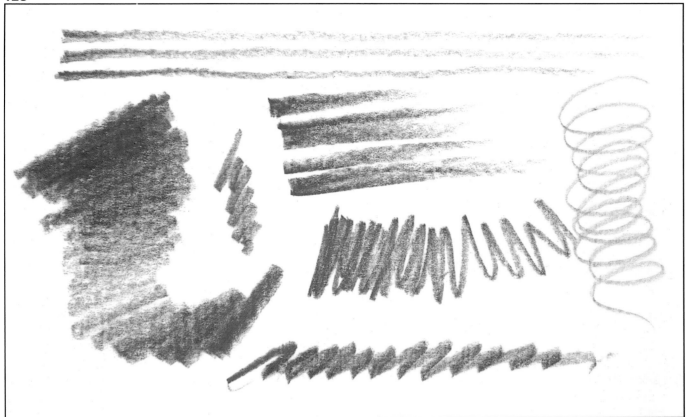

129

Once you've completed all the preceding exercises, review your results. If you're not completely happy with all of them, don't be too self-critical. Instead, use these exercises to tell you where you need to practice more.

At this point, my best advice is that you take a piece of paper and draw all kinds of lines on it, combining strokes with shadows, lines, gradations, and other marks (fig. 128). Dare to experiment and explore all the possibilities that the pencil can offer.

I urge you to keep a sketchbook and repeat the foregoing exercises for a few minutes every day until you've completely mastered them (fig. 129). Don't forget to take your sketchbook with you on weekends away and longer vacations so that you can keep up with your practicing.

Don't throw away the practice sheets that you think are terrible; keep all of them so you can later see how much progress you've made. Continued practice will enable you to master the technical possibilities offered by the pencil, and learn to get the best out of it.

Figs. 128 and 129. Experimentation is always productive. Take a piece of paper or notepad and simply draw meaningless lines, employing all possible positions of your hand and all kinds of strokes. In time, you'll find that your pencil will draw not only basic strokes, but also unexpected effects and tonal gradations to animate your drawings.

TIPS

Keep your drawing arm loose and flexible. The best work is done not only by moving your hand, but by moving your forearm, as well.

For sharpening pencils, I recommend a single-edged razor blade or knife, which will give you the most control over the shape, length, and point of the lead.

Always try to work on paper of the right weight and texture, because paper surface contributes greatly to achieving the look you want in your drawings.

Composition Exercises

One of the simplest ways to get started on a drawing project is to experiment with the composition of your subject matter. In this exercise, you'll find that by varying the space, the arrangement, and the organization of objects, you can either improve or mar the quality of a composition. And that's exactly what you are going to do: compose.

Take the ruled guide sheet number 2 at the back of the book. Note that it's divided into four squares designated A, B, C, and D. For the first exercise, we'll use square A, top left on the sheet.

Now look at the illustrations on these pages drawn by Bibiana Crespo, an artist who teaches printmaking. Study the examples she's developed for this exercise.

After deciding whether the format shall be vertical or horizontal, Bibiana considered how to organize her drawing. She began by establishing a basic division with a horizontal line that divided the surface into two parts. But she also added a second division by drawing a vertical line through the horizontal one, forming a cross. (These lines, drawn very lightly as a first step, are no longer visible.)

As you can see, the exercise consists of three sketches of the same still life, which allows you to study how the objects are affected by their relationship to the picture plane, the

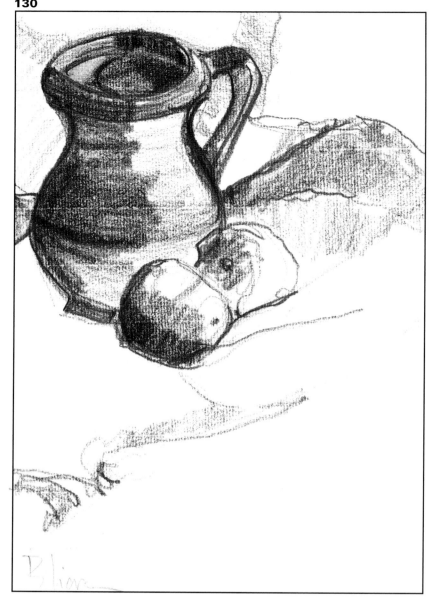

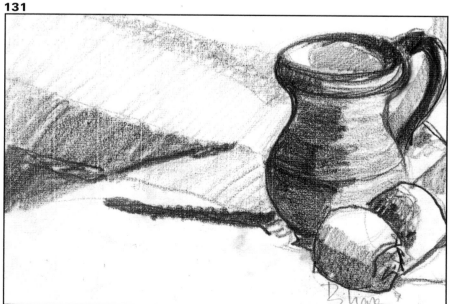

Figs. 130 and 131. To determine the best format for a still life, move the grouping around—toward the sides of the paper, higher up, farther down. This exercise is an excellent way to study composition and choose the best layout for a drawing.

132

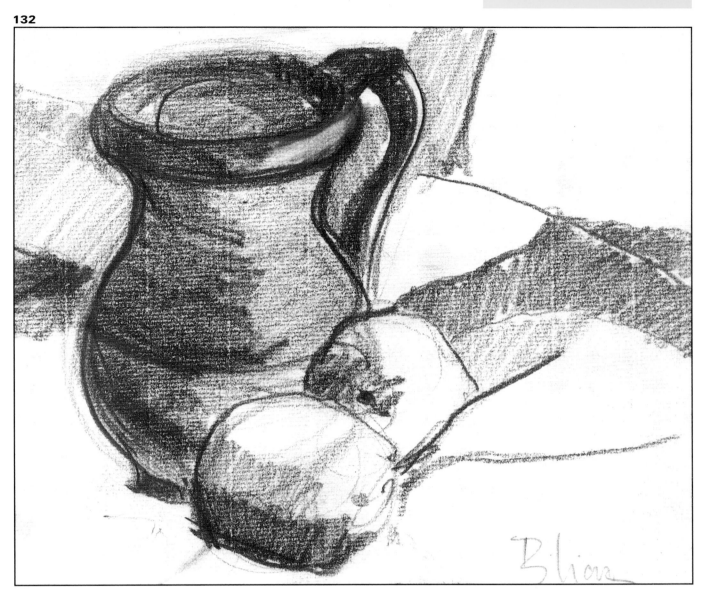

format of the paper, the placement of individual items, and the artist's vantage point as she drew.

In the vertical format (fig. 130), the artist concentrated her motif in the upper left corner of the picture. This makes the eye travel upward and creates an asymmetrical composition that leaves a great deal of blank space below.

On the other hand, in the second example (fig. 131), it's clear that the model is too far off-center. The composition doesn't offer a compact view of the whole. On the contrary, it's disturbingly unbalanced.

Finally, a perfectly aesthetic composition (fig. 132) is presented, showing unity based on the order of the whole picture, the vantage point, and the arrangement and placement of elements in the work. In this third example, the artist has applied the rule of the golden section which enables her to situate the motif in the best spot.

After studying these examples, spend some time taking objects that you find at hand and arranging them for still-life drawings, referring to the basic guidelines set down in the "Fundamentals" chapter (under the heading "Composition"). When your composition is visually satisfying, offering both unity and variety, draw it in square A, applying the law of the golden section discussed earlier. As you can see, the square is inscribed with a cross that signals the golden section (the intersection of horizontal and vertical lines). Now all you have to

do is place the model at the indicated point and begin to draw. This exercise teaches how, through observation and practice, to select the best composition for your work.

Fig. 132. Don't you agree that this composition, as compared with the two on the opposite page, is a more balanced and pleasing arrangement for this still life?

59

Now let's practice another basic principle in the art of composing: representing the overall form of the work by a geometric shape.

For this exercise, Bibiana has already selected two geometric plans. The first is created by a straight diagonal line that crosses the paper from the upper right corner to the lower left (fig. 133). Once the plan is chosen, the rest is "a piece of cake." With a few pencil strokes, the artist then scales the composition according to plan, and, in a few minutes, she has sketched a landscape scene of the seashore. Note how the diagonal corresponds to the shoreline.

Looking at Bibiana's second sketch, which is based on a parabola as the geometric configuration, note how the house is inscribed within that shape and how it is formed by the vegetation along the edge of the road (fig. 134).

Try your own drawings by using squares B and C on guide sheet number 2. The squares are marked with the diagonal and parabolic plans described here. All that remains is for you to choose a subject, one that suits these geometric plans. It would be preferable to draw something real, but if you're

133

stumped for ideas, for the purpose of this exercise, just copy the subjects offered here. Even if you use another artist's composition, the final interpretation will depend in great part on what you bring to the drawing through your own imagination.

Figs. 133 and 134. A strong diagonal is the basis of the above composition, while a parabola guides the landscape shown below.

134

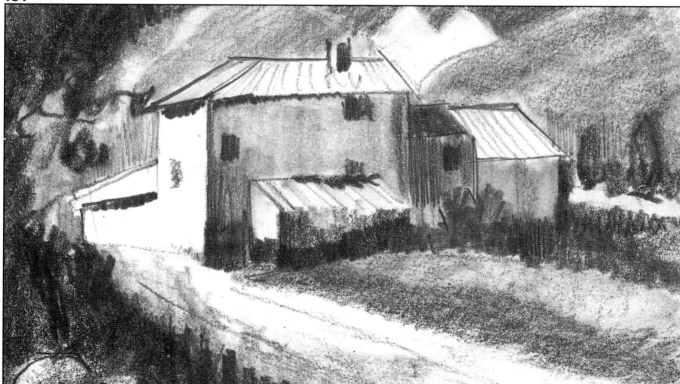

You read in earlier pages about Cézanne's famous contention that everything in nature is based on simple geometric forms—the cube, the cylinder, the sphere, the cone. In the following exercise, Bibiana Crespo shows exactly how to apply this principle by scaling objects based on geometric forms and also choosing a geometric plan for the entire composition (fig. 137).

Of course, all other aspects of composition that have been presented so far may also be seen in this example.

Do this exercise in the lower right square on the same number 2 sheet.

The process is quite simple, as you can see. First, select a compositional plan. Second, draw the layout of the objects as geometric figures (cylinders, cones, spheres, cubes). Finally, begin to give the ensemble definitive form. After studying your subject matter, remember to analyze its artistic possibilities, checking to see if it offers a geometric plan. Then, if you feel so inclined, change or improve the arrangement and modify the forms.

135

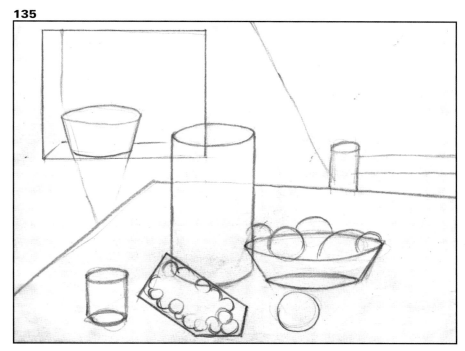

Fig. 135. Once again, we see how beginning with basic geometric forms can guide the structure of a drawing. Fig. 136. Even in this fully developed still life, it's still easy to find the geometric structures that underlie it. Fig. 137. This still life's overall geometric plan reduces to two dominant shapes.

137

136

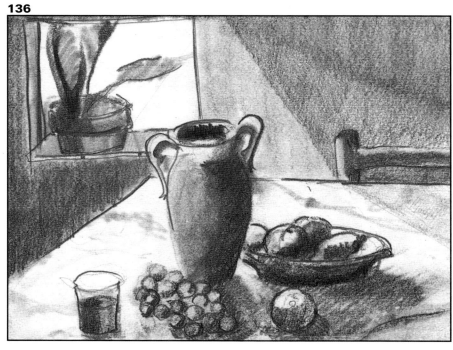

Using Basic Geometric Shapes

I consider geometric shapes important enough as a foundation for drawing to warrant repeating, yet again, that if you analyze the structure of any object, you'll find that it can be reduced to basic geometric shapes. If you can draw those basic shapes, you're on your way to being able to draw almost anything.

In the following exercise by Bibiana Crespo, do you see the basic shapes that underlie the pitcher, two apples, and a mortar and pestle? Developing these items (fig. 138) into a drawing is an exercise that will strengthen your awareness of shape and form and give you a chance to translate theory and principle into practice.

In preparation for this step-by-step exercise, take guide sheet number 3 from the book, and assemble the following: a stick of 6B graphite; a stick of 4B graphite; a kneaded eraser; and a large stump (at least a no. 4).

Seat yourself as Bibiana did in working on this example, directly in front of your still life in a comfortable position. After observing and deciding the amount of space your still life will take up on the paper, pick up the 4B graphite stick. Begin to scale the objects, representing each by using a geometric form: a cylinder for the jug; two spheres for the apples; a cylinder for the pestle; an inverted cone for the mortar (fig. 138). A scale sketch using geometric figures makes it easier to calculate the proportions and correct dimensions of the objects. At this point, the shapes don't have to look a lot like the objects they represent. As the exercise continues, they'll take on definitive form.

Next, following the initial geometric plan, begin the real drawing with the same 4B lead, sketching the contours and simultaneously adding shading with the 6B lead, held sideways. Draw the handles and neck of the jug, the approximate shape of the pestle, and the mortar (fig. 140).

138

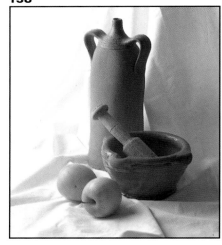

Fig. 138. A ceramic jug, two apples, and a mortar and pestle, washed in intense light from one side, provide an ideal set-up for a still life.

139

Fig. 139. To practice what you've learned up to now, begin this still life by reducing each of its objects to basic geometric shapes.
Fig. 140. As you loosen lines, let them overlap, begin emphasizing some over others, start shading, and objects will soon take on their proper form.

140

141

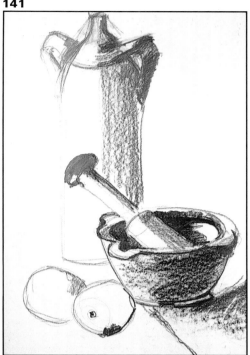

Fig. 141. Now the broadest areas of shadow are introduced.
Fig. 142. Working with the pencil held sideways, the darkest areas of the jug, the apples, and the mortar are accentuated.
Fig. 143. Those gray areas are now rubbed with a stump, which is then used on areas not yet touched by the pencil. The stump is recommended for creating medium tones.

142

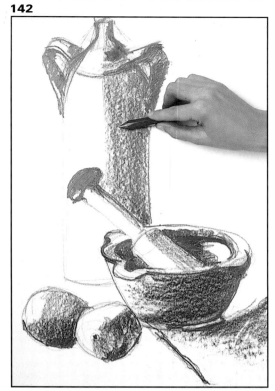

In this step, using more intense strokes, model the approximate forms of the objects, with curved lines representing indentations or other irregularities that characterize the real objects, little by little substituting curved lines for the straight ones in the scale sketch (fig. 141).

Once the preliminary drawing is completed, fill in the most striking tones. The shadows help to establish contrast and volumes and to make the composition solid and convincing. A second range of values that intensifies the initial tones helps define the principle areas of light and shadow in the composition (fig. 142). Note that when the artist has established the main motif, she continues to add shading, further clarifying the contours of each item. This manner of drawing with graphite results in a grainy shadow that makes the still life seem to come alive.

Now the artist alternates the use of the graphite stick with the stump (fig. 143), taking graphite from the darkened areas and adding grays to areas as yet untouched. Now the folds of a background cloth are made substantial and voluminous.

143

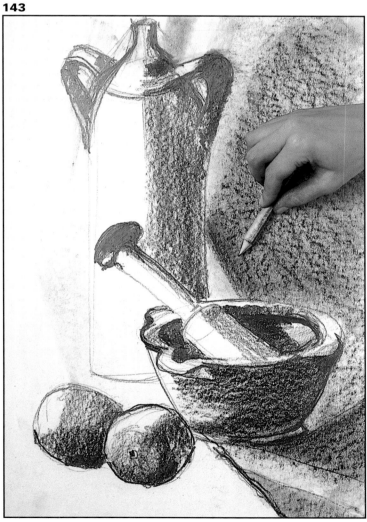

Following Bibiana's example, this is the time to draw lines to define the contours of the objects as realistically as possible (fig. 144). Then with the aid of an eraser, the next step is adding touches of light to the neck and handles of the jug. Again using the stump, the artist darkens the illuminated area to the right of the ensemble, so that the illuminated side of the jug is defined.

The different tones of the pestle will stand out by using circular strokes with the stump, so that the object takes on its cylindrical form (fig. 145).

Now there is little left to do but to strengthen the middle tones and extend the cast shadows to reinforce a sense that the objects rest firmly on the table (fig. 146). The eraser is used again to add highlights to the apples and the lip of the mortar.

144

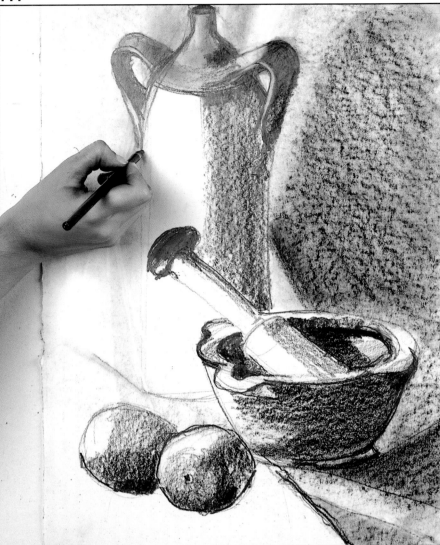

Fig. 144. Now the artist draws precise lines to define the contours of objects as accurately as possible.
Fig. 145. Middle values and shadows are refined, then a kneaded eraser is used to bring highlights to the neck and the handles of the jug.
Fig. 146. Shadows on the apples and the mortar, as well as cast shadows, have now been intensified.

145

146

147

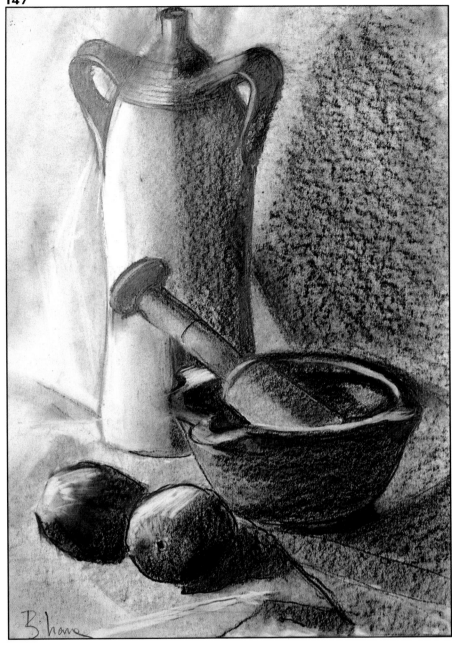

This beginning exercise is very important for the success of all your drawings, because one of the secrets of successful drawing is knowing how to simplify objects into their basic forms.

As a final step, study the jug in the exercise and compare it to the one you have drawn. Focus for a minute on the way Bibiana Crespo has represented light (fig. 147). If you look carefully, you'll see how she creates a fine progressive gradation of tones, beginning with pure white on the left, moving toward a middle tone in the center, and ending with more intense shadows. Also note how effective the skillful use of the kneaded eraser has been. Applied in a circular motion to the neck and handles of the jar, the erasure technique imparts the suggestion of an actual glazed finish. Possibly you didn't notice that detail at first and didn't capture that effect in your drawing. If that's the case, you can correct your drawing easily by rubbing a stump over the area you want to change, then erase it.

Fig. 147. Now artist Bibiana Crespo has added final touches to her drawing. As she did before deciding that her drawing was complete, before determining that yours is a finished work of art, move away from it for another view, then move closer and look again, until you're quite satisfied that your drawing is ready to be framed.

TIPS

It isn't necessary to use a ruler to draw geometric shapes. Sketch them freehand and don't worry if they aren't perfect at the beginning, because they will be straightened out as your drawing progresses.

You should get used to alternating a pencil or stick of graphite with a stump. Think of the stump as both a pencil and a brush.

Drawing with an Eraser

Generally we think of using an eraser only to remove or rectify errors in a drawing. But erasers are far more versatile than that. In the following exercise, we'll explore how an eraser can also be used as a drawing instrument to create special effects of great clarity.

When your subject matter offers strong contrasts between light and dark, an eraser technique can be very useful in expressing the effect that light produces on objects. It's an interesting approach to drawing that produces good results.

My earlier advice that squinting is one of the best ways to distinguish areas of light and dark can be used to

148

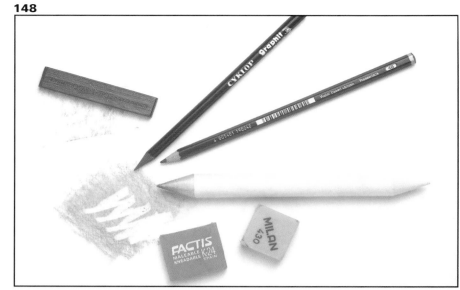

149

Fig. 148. Not all erasers work for opening up white areas in a medium as greasy as graphite pencil. If you're going to use a rigid, rather than a kneaded, eraser, make sure that it has some flexibility and absorbency and that it's not colored, which can stain your paper.

Fig. 149. As shown in the photograph chosen for this exercise, this pleasing still life includes a basket with fruit, onions, an apple, a pitcher, and a bottle. Everything is placed against a white background, with illumination coming in from the side to sharpen the contrasts between light and shadow.

Fig. 150. Because this exercise uses an erasing technique, first we cover the white paper with graphite, so that the drawing can evolve from dark to light.

150

great advantage in this exercise. By looking through half-closed eyes, you'll find that objects appear more contrasted. In fact, you'll see harder tonalities than are really there, which will definitely help your drawing.

For carrying out the erasure technique employed in this exercise, use sheet number 4 and these materials: an HB pencil and a 4B pencil or graphite stick; a kneaded eraser; a plastic eraser; and a stump.

The plastic eraser should be relatively soft. Note that an ordinary pink rubber eraser should not be used because it can stain your paper.

Arrange some objects with contrasting shapes into a still-life grouping. Use items that appeal to you and that you find easily at hand. Of course, you may opt to base this exercise on the photograph shown here (fig. 149) of a bottle, pitcher, and casual arrangement of fruit in and out of a basket.

Begin by darkening the surface of the paper (fig. 150) with an HB pencil or stick of graphite. Try to cover the paper with an overall, even shading.

Now rub the whole surface with a stump (fig. 151) until you've achieved an evenly distributed tone of gray. If it gets too pale, run your graphite over it lightly again.

After carefully observing your still life, with one of your erasers, begin to rub out white areas that represent the most illuminated parts of your subject matter. In the example here (fig. 152), the eraser has been rubbed against the paper until areas of pure white are created down the side of the bottle, the rim of pitcher, and so on. Note how this first round of erasing just suggests the items. Although it's still hard to see the exact shapes of the bottle, pitcher, fruit, and basket, this step is when all the items should be arranged and adjusted so your layout is just as you want it.

Keep erasing the toned surface, applying more or less pressure according to the different gradations seen in your subject matter, from the brightest light to various middle tones (fig. 153). The eraser lets us clearly distinguish illuminated areas that contrast with the graphite background.

151

152

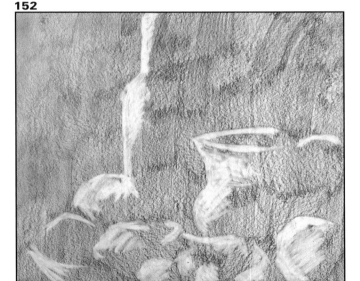

153

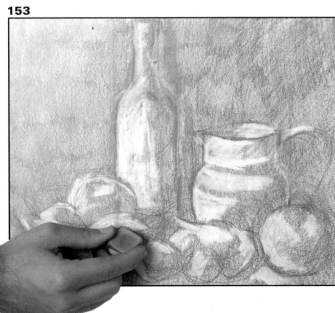

Fig. 151. A stump is used on the gray background to smooth out tones. If it lightens too much, more graphite can always be added.
Fig. 152. As light breaks through the gray background, objects in the still life begin to emerge.
Fig. 153. As tonal gradations are developed further, all of the objects become more clearly defined.

154

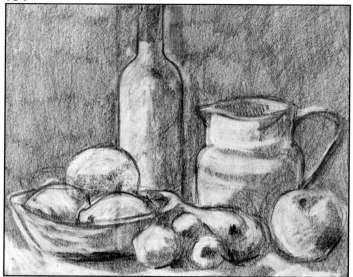

155

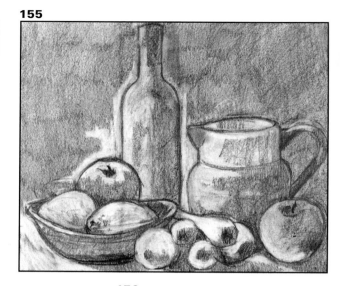

156

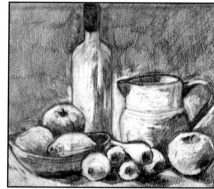

Even though the forms of the objects are more clearly defined by this step (fig. 154), take your HB pencil and lightly outline each item. Try not to overdo it; the objective is to achieve an effect of diffused contours rather than sharp outlines. Guided by the light zones that give form to each item, we must now more clearly establish relationships between objects.

By now, the basic forms of all items should be perfectly delineated (fig. 155), with main areas of light and dark clearly distinguished. Now is the time to draw with a pencil, trying to tone, model, intensify shadows, and further separate light from shade.

Now put into practice what you learned earlier regarding scales of tonal gradation. Using both your HB and 4B pencils and varying pressure as you work, create a series of values that

represent the whole spectrum of grays and blacks called for by the composition (fig. 156). Enhance the realism of the fruit and pitcher by adding tones progressively to create surfaces modeled by light. These refinements enable viewers to distinguish little details and better appreciate contrasts among various elements of the composition.

To emphasize the forms and volume of all items, begin to erase the background (fig. 157). When you substitute a lighter background, your still life jumps out at the viewer, appearing darker and more emphatic because of the greater contrast created.

Continuing to refine details (fig. 158), shadows have been intensified and further accents added, including cast shadows made by various objects.

Figs. 154 and 155. Pencil lines are now added to lend further definition to each object in the still life.
Fig. 156. Tonal values are altered here and there to accent contrasts between different elements of the composition.
Figs. 157 and 158. After lightening the background by erasing, the objects seem to pop forward and take on a more realistic look.

157

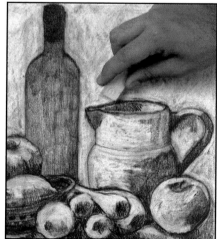

TIPS

When you use an erasure technique, forms and volumes are more important to concentrate on than lines and details. Those refinements can come later.

Always keep your erasers clean. A kneaded eraser is self-cleaning; just pull and reshape it as you work. Clean other erasers frequently by rubbing dirty parts on scrap paper.

If you make mistakes when erasing, they are easily corrected by reinstating some graphite in that area and beginning again.

158

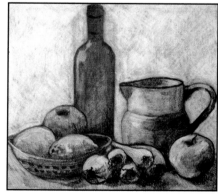

159

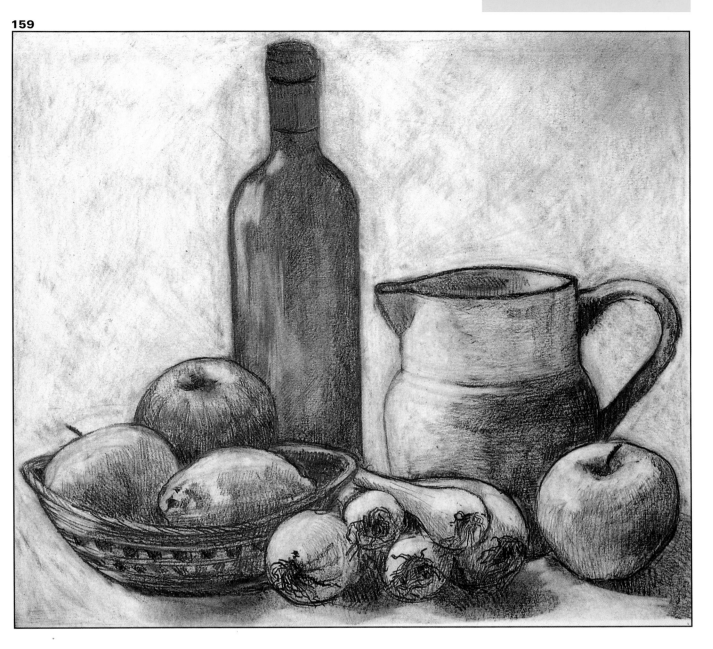

Don't worry if your drawing isn't perfect. The main objective of this exercise is for you to learn to compose and construct the volume of objects through careful observation of how light falls on them.

Also, this method of working from dark to light forces you to observe objects through keener eyes. Using pencil and eraser to equate shadow and light is also an interesting way to construct a composition by working from the general to the specific, from broadly illuminated areas to concrete details.

Practicing the erasure technique will help your general understanding of the steps that go into creating an effective tonal drawing. Each step reinforces your skills at illuminating and shading a composition and integrating the two in a continuous, gradual, and modulated way.

Fig. 159. A lot of time is spent refining small details, particularly the texture of the fruit and the willow basket, before the drawing is declared completed.

Shading Objects

Aida Sánchez de Serdio is the artist whose work is featured in this exercise. She began by arranging and photographing (fig. 160) a casual still life of fruit and a few items found in her kitchen. Her objective is to capture the effects of light through the use of soft, diffused tones. An intense light falls on her still life from one side, emphasizing the contrasts between light and shadow.

Use sheet number 5 for this exercise. You will need an H pencil; a 6B pencil; and a kneaded eraser.

Aida begins by sketching in structural lines (fig. 161), using her pencil as a measuring device to estimate distances by eye between many different points. Gradually, building from her initial blocking lines, she begins developing each item until it stands out clearly. For this first step, Aida uses her hardest pencil, the H, making both straight and curvilinear pencil strokes. It's important that the first sketch resembles the real objects that the artist sets out to represent. However, don't worry about precision at this point. There will be plenty of opportunity to correct and modify your initial sketch as you proceed.

Holding her pencil on an angle (fig. 162), Aida begins to tone the model by applying broad areas of gray, still using her H pencil. The pencil point glides smoothly over the paper, caressing it lightly to set down her most subtle tonal gradations.

As this artist has done, in the early stages of a drawing, it's good to keep values on the light side (fig. 163). Later, many other values can be layered on top until more intense contrasts are attained. In Aida's composition, you can see that this early step only indicates areas in which shading is darker. She's just beginning to give the drawing a sense of depth and volume.

160

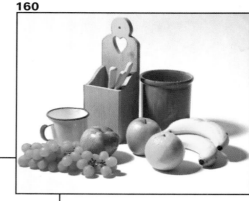

Fig. 160. This still life shows a good interplay of varied shapes, lights, and shadows.
Fig. 161. The initital drawing is rendered in very light pencil lines.

161

162

Fig. 162. With the pencil held on a slant, the artist sketches light grays, pressing on the pencil lightly in order to create a delicate veil of tone.
Fig. 163. After the first tones are applied, the artist begins to define forms, working from less to more.

163

164

Fig. 164. A second tonal allocation, just like the prior one, is applied very softly. By skimming the pencil over the paper gently, the surface texture remains visible and contributes to the quality of the drawing.
Fig. 165. Now a softer pencil is used to sharpen contrasts in the drawing.
Fig. 166. The finishing step entails intensifying the darkest shadows in small areas. Final touches are made where adjustments and reinforcements are needed.

165

166

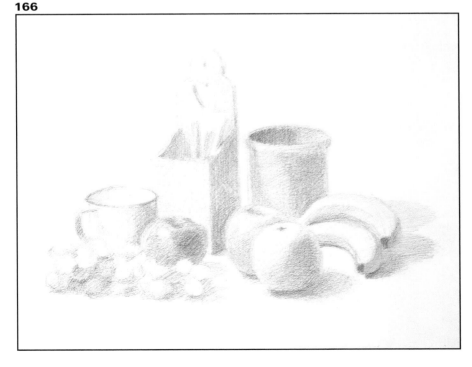

Now more detail is added (fig. 164) as the artist accents tones, pressing on the pencil more and more firmly, reinforcing the darkest parts of the utensil box, ceramic jar, cup, and their projecting shadows. Her pencil glides across the surface as she superimposes some tints over the first pale-gray areas, progressively intensifying and deepening the general tonalities of her composition. Note the introduction of deeper tones on the jar, the interior of the box, the side of an apple. You can see how different gradations—light, half light, shadow, and reflected light—become increasingly distinct. Some attention is also given to shadows cast on the tabletop.

Aida reserves developing the lighted side of the utensil holder and the shape of the bunch of grapes for her last step, when the fruits will also be given more intense tonal contrasts so that their shapes become more realistic. For now, notice how she has stayed within three basic values: illuminated areas, where the paper remains white; middle tones, in light grays; and a third gradation that is somewhat more intense, used for the darkest, most contrasted shadows.

In her last step (fig. 166), the artist uses a 6B pencil to reinforce the contrast among various elements. Then she emphasizes the cylindrical form of the jar and cup with light, circular strokes. With the same pencil, somewhat sharpened, the forms of the utensil box and the lip and handle of the cup are reworked. Other finishing work includes intensifying the darkest shadows and bringing definition to the whole with little accents and touches here and there.

Finally, a pointed corner of kneaded eraser picks out areas of light on the table and little highlights on the cup, the fruit, the jar, and the utensil handles.

TIPS

The most effective, eye-appealing still lifes contain items of contrasting shapes and textures.

When you establish tonal values, don't lose track of the ensemble as a whole. Work all over a drawing as you proceed, instead of concentrating on one area before going to the next.

For sections where you want the most blended effect, use a stump for smoothing tones.

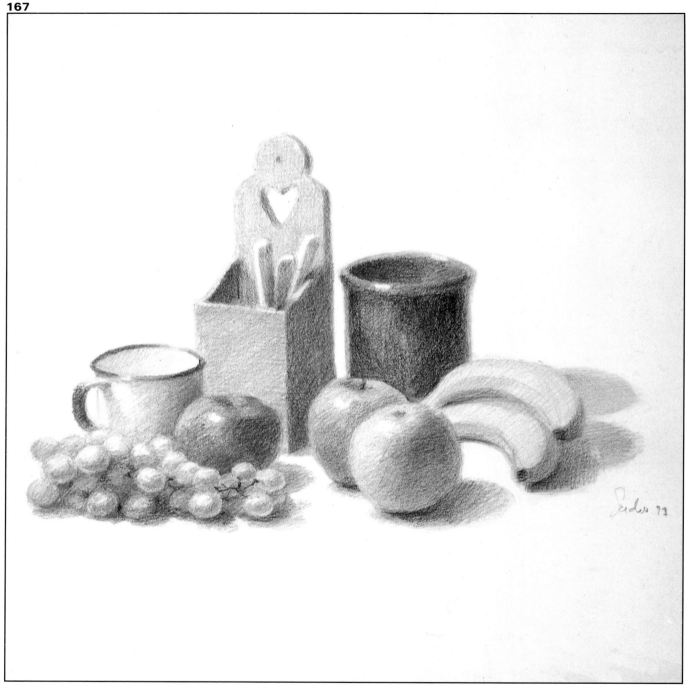

As her completed still life shows (fig. 167), Aida's technique of laying on successive tints of graphite results in few obvious lines or pencil strokes. This diffused look is achieved by holding the pencil lightly on the paper's surface, rather than pressing down on it. But if too many lines are apparent in your exercise drawing, don't worry. Next time you draw using this technique, just remember that the pencil should skim the paper surface with minimal friction and no force.

Also note that the artist has softened the shadows seen in the actual arrangement of items that inspired this drawing, so that her artwork appears much more atmospheric than the items were in life or in her photograph of them. If your drawing doesn't have this quality on your first attempt, you'll surely achieve it as you continue to practice tonal gradation.

Fig. 167. The drawing technique based on successive layers of tone produces an appealing, diffused effect. The still life seems cloaked in a gentle mist that blurs sharp outlines.

Drawing Rustic Buildings

One of the most popular genres of drawing is landscape, both urban and rural. The city presents obvious problems of perspective, such as buildings oriented at varying angles and long avenues of trees. But country and village landscapes also entail understanding perspective and resolving other problems of spatial representation. But even if you aren't too familiar with the laws of perspective, there are some simple ways of handling it in your drawings.

By observing and comparing the angles of lines and the points at which they cross, you can give settings an adequate illusion of space, volume, and the correct distance between objects and yet avoid the more difficult aspects of rendering perspective.

For the following exercise, I've chosen a cluster of rustic buildings, a scene that shows houses in the foreground, without a street that moves

169

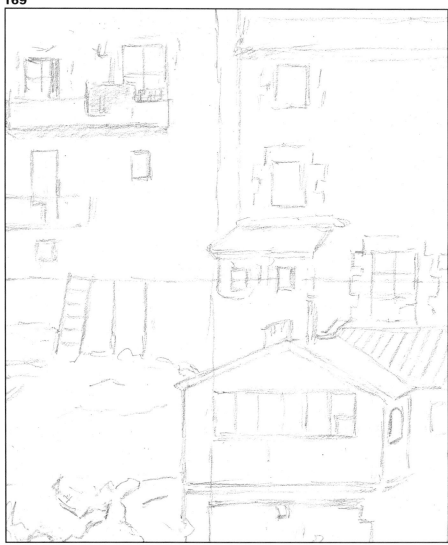

168

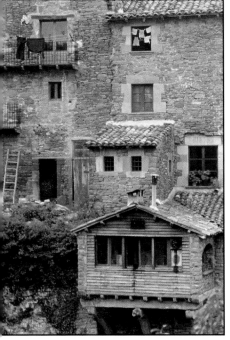

Fig. 168. I've chosen this photograph as inspiration for a drawing because it's simple, concrete, and offers enough formal and tonal variety to result in a beautiful picture.
Fig. 169. By dividing the paper in quadrants, the calculations of dimensions and proportions are made much easier.

into the distance, thereby eliminating one of the more complicated aspects of perspective.

With sheet number 6, assemble these materials: a 2B pencil; a 6B pencil; a stump; and a kneaded eraser.

My photograph (fig. 168) of a tight grouping of village buildings offers many textures (bricks, tiles, wood, foliage) and tonal contrasts that make good subject matter for a pencil drawing.

After observing and studying the scene for as long as necessary, I begin a mental calculation of the dimensions and proportions of the buildings.

The first marks I make on my drawing paper are two lines, one horizontal, one vertical, thereby dividing the sheet into equal quadrants (fig. 169). Using my pencil as a measuring guide, I begin to scale and

draw the structures as they relate to one another, noting that the center of the picture is at the line between the houses in the middle ground. At this point, it's important to establish the basic structure of the composition, which I do by lightly blocking in each building, sketching the general shape of each structure. Then I draw in other basic features, such as the bare outline of windows and the bushes at lower left.

Now, I more precisely elaborate the scene by adding significant details (fig. 170) to define the buildings' balconies, windows, and doorways. On the windows and other openings I use my 6B pencil, an intense black, and am careful to control the uniformity and consistency of lines. I also add light gray tones to continue developing the balconies, using somewhat darker grays for the shadows they cast.

170

171

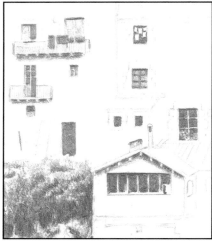

172

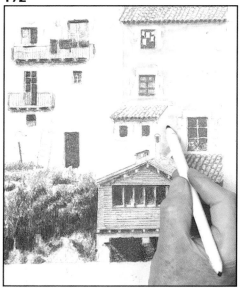

Figs. 170 and 171. I begin by darkening windows and other openings, then introducing subtle tonal values to suggest forms and the contrast between the foreground and middle grounds. Figs. 172 and 173. After intensifying the shadows, I fill in the middle tones using a stump loaded with graphite.

Next, I continue sharpening tonal contrasts (fig. 171) so that they stand out against the uniformity of the background. When sketching in the shrubbery at lower left with special attention, I use free, looping pencil strokes that add liveliness to the composition. At the completion of this phase of the drawing, I've sketched out all the essential forms that define the buildings.

Important details are refined in this step (fig. 172): window frames, the stonework bordering the windows, windowpanes, and doorways. Special attention is also given to the forms of roof tiles and their sloping angles. But don't overwork roofs by drawing each and every tile exactly the same way. When the subject is an old building, keep in mind that there should be a certain irregularity in tiles, bricks, and stones, which will add to the charm of your drawing.

173

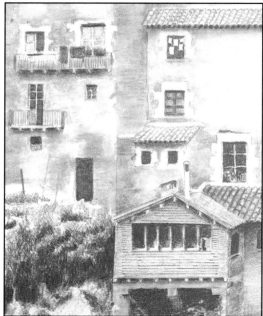

TIPS

Every representation of space begins with the construction of a simple framework of horizontals and verticals. For the houses in this exercise, begin with basic squares, rectangles, and triangles, the obvious geometric shapes that underlie this subject matter.

If you apply light pressure on your pencil, it will be much easier later on to erase and make corrections.

174

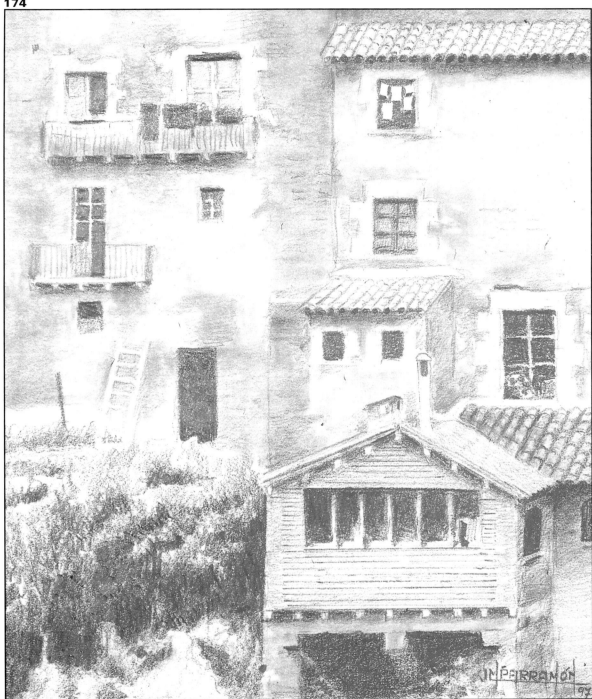

Notice how the intensification of values (fig. 174) helps to establish spacial planes and create a sense of volume. Darkening values and adding more definition to the plants and shaded areas in the foreground, while keeping areas farther back lighter, gives the picture a sense of depth. Further work with both a stump and kneaded eraser produced tonal gradations throughout the drawing.

In terms of creating a lively pattern of light and shadow over the walls of the houses, here is a procedure I would recommend for achieving the effect you see in my finished drawing of these rustic buildings.

On a piece of scrap paper, use a 6B pencil to create a patch of deep gray. Rub the tip of a stump into the gray until it picks up some graphite. Use this light gray to tone wall areas of the houses. Note how the tones vary over the buildings.

Fig. 174. My finished drawing shows a variety of pencil strokes that are clearer and better defined in the foreground areas, while the most delicate and softest lines are reserved for the more distant planes of the buildings that are farthest from the viewer.

Atmospheric Landscape Drawing

One of the greatest side benefits of drawing in pencil is the pleasure of working easily on location, out of doors, enjoying nature's wonders. But a major technical problem for the artist is how to bring a sense of depth and distance to a drawing restricted to pencil.

The following exercise offers good practice in doing just that. Ester Llaudet, the artist whose work is featured, has drawn a scene in the Pyrenees, beautifully capturing its great distance and depth through atmospheric perspective. Her mountain landscape has a large lake and boulders in the foreground.

For this exercise, use sheet number 7 and these materials: a 6B pencil or graphite stick; one each 2B, 4B, and 6B pencils; a small and medium stump; a kneaded eraser.

The artist begins establishing the basic forms of the landscape (fig. 175), using a small stump on which some graphite has been rubbed. She sketches in the profile of each plane: mountains in the distance; lake in the middle distance; growth and boulders in the foreground.

After loading the medium stump with graphite, she begins to darken the most distant areas (fig. 176), defining the uppermost part of the mountains, smudging her graphite lines with the stump. This is just the first step in toning the drawing, but already, contrasts begin to delineate shapes.

After filling in the irregular peaks (fig. 177), Ester develops the distant mountains further with varied tones, transforming basic forms into real mountains marked by crevasses, crags, and shadowy depths.

175

176

Fig. 175. This landscape is blocked in with a small stump. The artist establishes just the most general outlines of different planes of the picture.

Figs. 176 and 177. By shading in the peaks of the distant mountains, the plane farthest from the viewer is developed first.

177

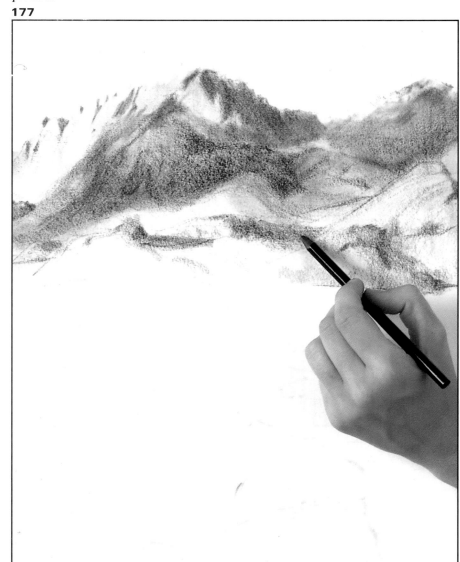

178

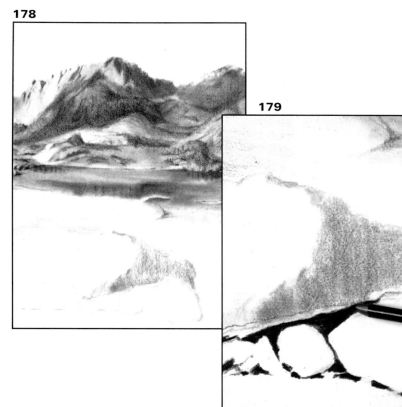

179

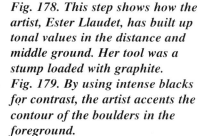

The artist uses the stump again, rubbing lightly on the paper to give a first tonal value to the rocks in the foreground (fig. 178). Returning to the mountains, she uses many grays to continue developing the valley, then the far shoreline and most distant part of the lake.

Now with her 6B graphite stick (fig. 179), Ester completes the rocks, redefining their contours and also emphasizing their dark areas and cast shadows with intense black.

To continue developing the lake (fig. 180), the artist brushes the medium stump lightly across the surface, first horizontally, to impart a sense of transparency, then, with the stump more heavily loaded with graphite, she makes vertical strokes to simulate reflections cast in the water.

Now the artist works on the foreground (fig. 181), detailing the irregular and complex shapes of the pile of rocks and a stand of fir trees to the left. Carefully directing her pencil strokes to follow the growth pattern of the trees, Ester represents them in a manner that is simple, but remarkably realistic. With a point of the kneaded eraser, she highlights some of the treetrunks in white.

180

Fig. 178. This step shows how the artist, Ester Llaudet, has built up tonal values in the distance and middle ground. Her tool was a stump loaded with graphite.
Fig. 179. By using intense blacks for contrast, the artist accents the contour of the boulders in the foreground.

Fig. 180. By using a stump on the lake, the artist gives the water an aura of transparency.
Fig. 181. Now Ester has shaded the scene lightly so that the contrasts between different planes of light and shadow can be distinguished.

181

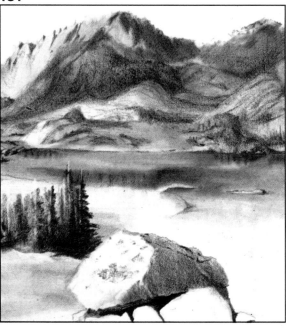

Within the broad toned areas she has created, the artist uses 2B and 4B pencils to add more fine details, accordingly making some parts darker and others lighter.

Heading toward the final stage of her drawing (fig. 183), Ester works with a 6B pencil to sharpen contrasts that can be discerned in the fields and in the grove of firs on the left. With the tip of the eraser she picks out light areas on the surface of the lake, on the road to the left, and in the mountains. She then retouches, defines, and darkens the foreground in order to sharpen the contrast with the background so that the latter seems hazier and more imprecise.

At this point (fig. 184), notice how the relationship between the more intensely accented foreground areas and the distance create the sense of atmosphere and interposed space. While the foreground details appear clearer, the distant mountains are grayer, less sharply contrasted.

182

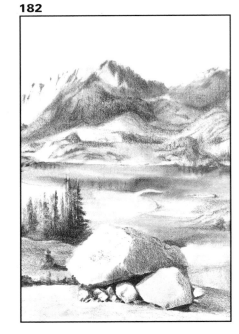

183

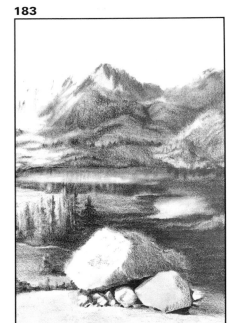

184

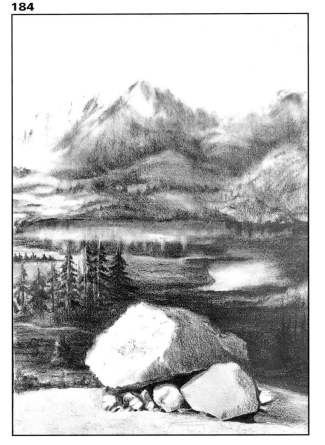

Fig. 182. The continued use of a stump gives the work more and more transparency. Also notice how the progressive tonal gradation of the meadows in the middle ground has enhanced the work.

Figs. 183 and 184. The forms of the distant hills have an appropriate misty air, having been drawn with a much more delicate gray than the more defined and contrasted tones of the foreground.

TIPS

Because of the effects of atmospheric perspective, values in general become lighter as they move away from us. Thus, trees in the foreground will appear much darker than the same species of trees situated in the middle ground or distance in your drawing.

Atmospheric perspective also causes shapes to become less distinct as they recede into the distance. So a pile of rocks in the foreground may show the shape of each individual rock, but in the middle ground or distance, should be drawn only in broad outline, showing the general contours of the grouping as an entity.

185

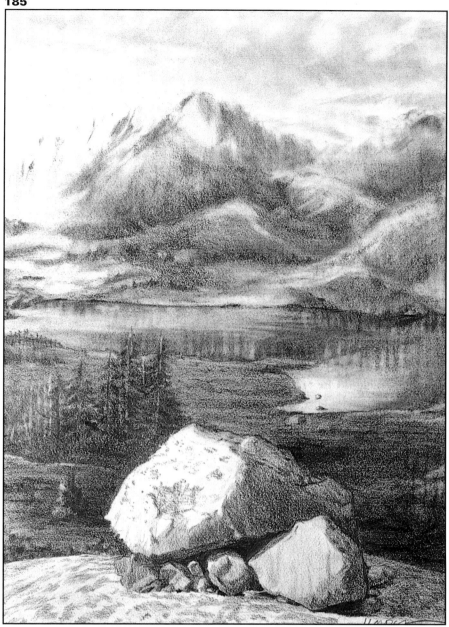

As a final step, using a stump loaded with graphite, Ester works on the sky until it takes on a pleasing range of tones and shapes. Then, with the point of a kneaded eraser, she brings lighter patches to all the clouds.

A landscape that takes in as many elements as this one—mountains, water, rocks, foliage—is a good exercise for understanding the relationship of tonal values and their effects on bringing depth perspective to a drawing. Besides ascertaining the effects of atmosphere, you can see how nature is composed of an infinite variety of colors from which an infinite number of values can be derived.

Notice the sinuous gray that describes the rough surface of the boulder in the foreground; the intense black that defines the bottom of the rocks; the gray of the firs in the middle ground; the reflection of the high mountain in the tranquil lake.

In your own landscape drawings, you'll find that by portraying a variety of nature's textures and tonal qualities, your work will become more pleasingly realistic. If that reality isn't coming through in a drawing, identify and correct specific areas that don't satisfy you. For example, if the foreground seems too vague, go back over it with your 6B pencil to intensify

objects that are closest to the viewer. By contrasting them sharply with the modified middle distance and paler far distance, reality will be reinforced.

Finally, don't worry if you can't quite replicate certain effects, such as the transparency of lake water, which is hard to achieve even for professional artists.

Fig. 185. This completed landscape by Ester Llaudet shows the infinite range of values that are so indispensable to creating reality in a drawing of this type.

Portrait Drawing with the Aid of a Grid

The photograph below (fig. 186) is of my granddaughter, Marta, taken when she was seven or eight years old. Using this photo as reference for a portrait drawing, we'll work with the tried-and-true grid system as an aid to producing an accurate facial resemblance.

The method entails drawing a grid on the photograph itself, which not only helps replicate it at its present size, but a grid also makes it very easy to scale an image up or down if you wish your drawing to be larger or smaller than the photo. You can also begin with a photo that's been enlarged on a photocopy machine; in fact that's preferable, as it's easier to draw from larger photos. If you'd rather not mark up a photo with a grid, place a piece of clear acetate over it and draw your grid there.

I begin by dividing the photograph into squares (fig. 187): eight rows across and ten rows down. Then I label the horizontal rows across the top with the letters A through H, and the vertical rows down the left side with the numbers 1 through 10.

In the photo I'm working with, in its overall 5 x 7" (13 x 18 cm) dimension, Marta's face measures exactly 4 3/8" (11 cm) from the top of her hair to the point of her chin.

Before moving to the next step, let me assure you that using photography and the grid system is an acceptable way to learn portrait drawing. Although drawing from nature is the most highly recommended method, there are times when copying from a photograph or another drawing is more practical. The trick—let's call it that—of using a grid was devised by old masters Raphael, Leonardo, Rubens, and others who painted cartoons (sketches) in grid form that were then transferred to murals or very large canvases. In more recent times as well, the grid system has been employed by Toulouse-Lautrec, Degas (fig. 188), and others.

As to the use of photography, since the earliest days of its invention, the camera has been used by many artists as reference and inspiration for paintings. Van Gogh wrote about plan-ning a painting of his mother based on a photograph of her, adding that when photography one day became technically perfected, it would be useful for painting marvelous works, a prediction that has proved true in the creations of many fine twentieth-century artists.

Figs. 186 and 187. I find children's faces to be quite inspirational subject matter for drawings, especially when the photo is of my dear granddaughter Marta. Drawing a grid on the photo (or on a photocopy of the photo) is my first step.
Fig. 188. The grid has been used as an aid by numerous great artists, as this drawing by Edgar Degas illustrates.

186

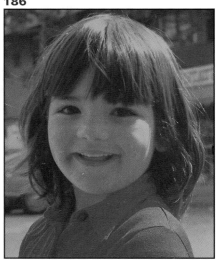

187

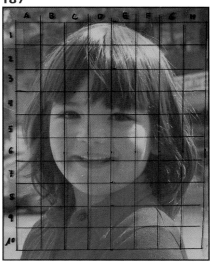

188

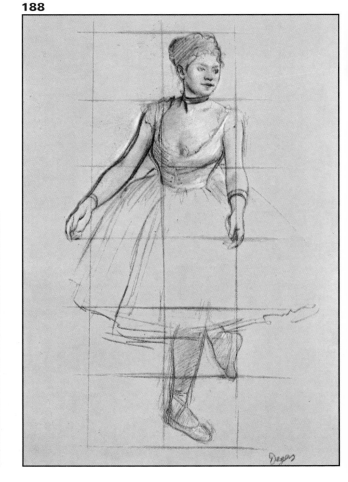

To begin my drawing, I create a grid on my drawing paper (fig. 189), using a ruler and T-square. For your work, use sheet number 8 and a 2B pencil. But for this exercise and in the future, in case you want to draw your own grid, make sure all the squares are exactly equal; a measurement of 3/8" (1 cm) square is a good working size. On the left, number the grid and alphabetize the squares along the top edge.

I start my drawing of Marta (fig. 190) with a sketch made to scale, achieved thanks to the grid. By following the common coordinates between the photo and the grid on my drawing paper, I simply transfer Marta's image bit by bit, beginning with just a few lines to suggest her hair, outline of her face, eyes, nostrils, and mouth.

My next step (fig. 191) includes completing the outline of Marta's hair, and adding the collar and shoulder of her blouse.

During this step (fig. 192), I erase the grid and continue developing the drawing.

You can see that even in this early stage, a resemblance has been achieved, because close attention is paid to the proportions of facial features guided to accuracy by following the dictates of the grid.

Note the dark accents at the inside corners of Marta's mouth and how her teeth are indicated only, not drawn tooth by tooth. One of the most telling mistakes beginners make in portraiture is drawing dividing lines between teeth, like little squares across the mouth. By leaving those lines out entirely, your drawing will instantly take on a higher, more professional quality.

189

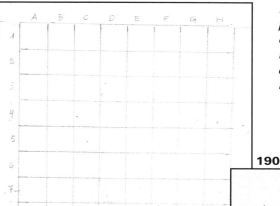

Fig. 189. On my drawing paper I rule a simple grid, coding the blocks with numbers 1 to 10 vertically and letters A to H horizontally.

190

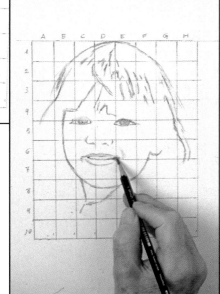

191

192

Figs. 190, 191, and 192. This grid corresponds to the one drawn on the photo, so that each square on the drawing has its exact equivalent on the photo. For example, since Marta's mouth on the photo falls within the squares labeled C-D-E/ 6-7, by placing her mouth on those squares in the drawing grid, accuracy is ensured. Once the scale sketch is completed, the grid is erased.

By adding tone (fig. 193), see how much life comes to this portrait? I begin tonal gradation with the hair. Notice how it is fully lit at top right and in shadow on the left. In terms of the direction of my pencil strokes, remember that lines should follow the shape, structure, and texture of what we are drawing, so my pencil strokes are mostly vertical, following the natural direction of the hair. I suggest that you sharpen your pencil frequently when drawing hair so that the point can produce masses of fine lines.

Fuller resemblance is obtained by finishing the eyes and the lips (fig. 194), which are refined through a range of values and accent touches. Now I also continue toning the cheek contours with soft grays.

Observe that the face is seen as though under an illuminated semishadow (fig. 195). From the beginning, I've left some areas completely white, representing reflections of light. If necessary, those areas can be lightened further with a kneaded eraser. I complete this step by using my finger to apply a few subtle touches of smooth blending.

Figs. 193, 194, and 195. Skin tones are drawn in light gray, blended by finger to smooth certain areas. Marta's hair is toned darkest black next to her face and around her neck, with bright highlights reserved for the crown. My most careful attention is given to shaping the lips and eyes, for accuracy is essential in depicting those features if a close likeness is to be achieved.

193

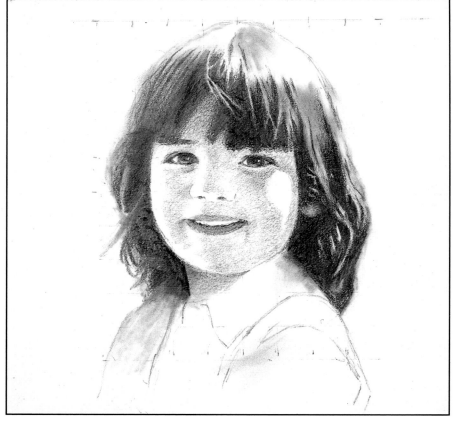

194

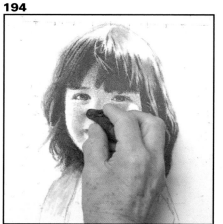

195

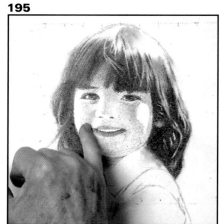

TIPS

Draw your grid with a light pencil so that it can be easily erased before completing your drawing.

For the purest white in your drawing, try to keep those areas free of pencil marks from the beginning. Paper white is the brightest value you can achieve, and although graphite can be erased, the pure, untouched paper is best for the very brightest highlights.

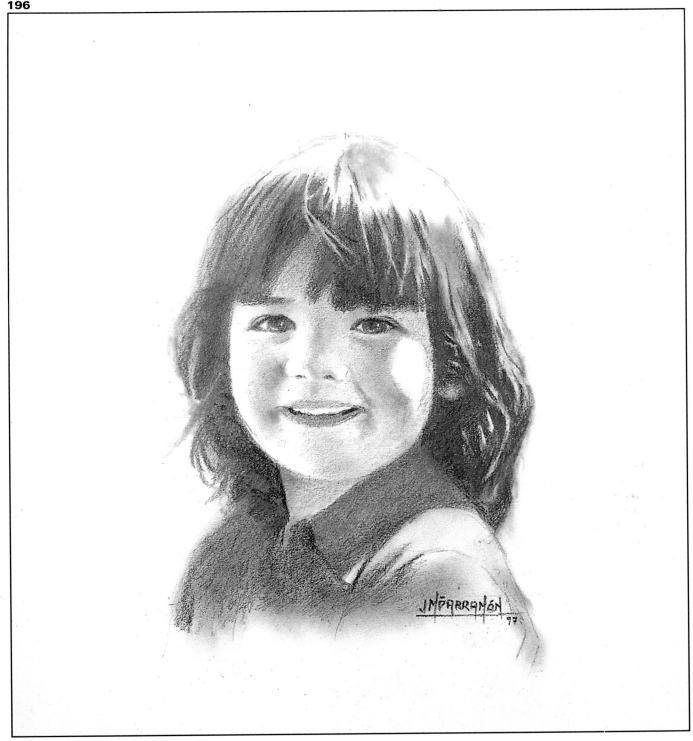

Finally, I've added little contour lines around the lips and eyes, deepened some shadows around the cheeks, and completed drawing and texturing Marta's blouse, employing the stump for blending.

The work is now complete. As to the degree of resemblance, by comparing the drawing to the photograph, I think you'll agree that exact likeness has been accomplished, which I attribute in large measure to the help of the grid.

I'm sure that you, too, will find the grid to be a very useful device for portraiture. After you've completed this exercise, use the grid method to work with photos of friends and family members, setting yourself the goal of drawing pencil portraits that are certain to become treasured keepsakes.

Fig. 196. It's self-evident how helpful the grid technique was in capturing Marta's essence in this pencil portrait.

Pencil Drawing with Wash

The photograph shown here (fig. 197) presents a lovely view of Santa Maria della Salute, a church in Venice, with characteristic gondolas in the foreground and middle ground. This exercise involves both drawing and painting, because the pencil I've chosen is water-soluble graphite. When liquid is applied to the lines made by this pencil, it produces a look of monochromatic watercolor. The tools I use are an 8B water-soluble pencil and a number 4 round watercolor brush.

Good water-soluble pencils (mine is made by Derwent) produce unusual wash effects. To take full advantage of them, practice the little test illustrated here (fig. 198). On a piece of scrap paper that has a lot of tooth (rough texture), rub the 8B water-soluble pencil very hard until it leaves a layer of graphite that can then be used as though it were a little cake of watercolor pigment. Then, by touching a wet brush to this patch of graphite, you can paint in a light gray tone.

For this exercise, use sheet number 9. As I usually do, I began (fig. 199) by ruling a vertical and a horizontal line, dividing my sheet into equal quadrants to help me with scale, dimensions, and proportions. After drawing in the scene lightly, I begin applying a wash on the main dome.

For a better look at the basic drawing, on the opposite page (fig. 200), note that my vertical line nearly coincides with the pinnacle of the small cupola. Based on that line, I drew that cupola and the main dome, seeing that the gentle curve of the latter meets the center of the smaller one, and that the lower curve of the larger one coincides with the pinnacle of the smaller one. Also note that the horizontal line coincides with the level of the row of windows that divide the composition nearly in two. I again emphasize that cross lines make it easier to achieve the correct scale and the resolution of dimensions and proportions.

197

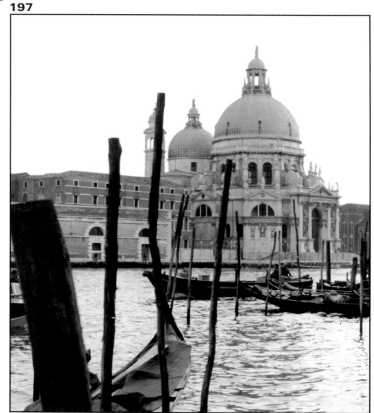

198

199

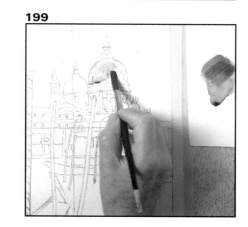

Fig. 197. This photograph of Santa Maria della Salute in Venice offers wonderful value contrasts to be interpreted in a pencil drawing. Figs. 198 and 199. If you rub a wet brush over water-soluble graphite, it's just like picking up hue from a cake, or pan, of watercolor. The wet graphite on your brush can be used to paint a light gray wash on a drawing.

200

201

202

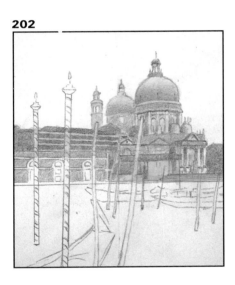

204

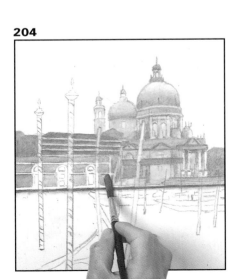

203

Fig. 200. My initial drawing was made on a sheet of paper divided into quadrants to guide correct proportioning of elements within the scene.

Fig. 201. With a wet brush, I apply a primary wash on most of the drawing, a lighter wash on the water in the foreground, leaving the sky untouched for now.

Fig. 202. After the paper has dried, I add strokes of gray to bring out details, using an 8B water-soluble pencil.

Fig. 203. The gray must be regular and even, applied in circular strokes. Practice on another sheet of paper before working on the drawing.

Fig. 204. By passing the wet brush over the grays applied with pencil, I dissolve and blend individual pencil strokes.

By dampening the brush and touching it to the patch of graphite I created on another piece of paper, I obtain a wash with which I paint the whole building (fig. 201), only skipping a few areas in the columns on the right and the doorways on the left.

I wait until this general wash dries, and then begin to intensify areas with the water-soluble pencil (fig. 202), working on a tonal gradation of more or less intense grays, but not yet adding pure black.

It's particularly important to be sure, when toning with water-soluble graphite, that grays are smoothly applied over the surface. In order to achieve this evenness of tone, I recommend that you use very tiny, tight, semicircular strokes (fig. 203). This technique produces a uniform application which, after adding water, will result in a perfect gradation of tones.

Regarding the use of an eraser with water-soluble pencil, there are two kinds of eraser that may be used with this technique: a rigid plastic eraser for erasing relatively broad areas, and a kneaded eraser that can be shaped with the fingers to obtain points of light and thin lines such as those along the bottom of the main dome.

Also remember that when bringing watercolor technique to a drawing, it's always essential to work from less to more. That is, we try to establish tone with a single wash, and since we cannot lighten dark tones, we must start light, then build up to darker tones by adding veils of wash to intensify values.

Having completed my tonal gradations with the water-soluble pencil, now I use my brush (fig. 204) and begin diluting the pencil lines. The general wash is complete, but now I work on each area separately, painting a selected part, cleaning the brush, then painting another area in a different tone.

To draw-paint on a wet surface creates the most intense black, the value that I now introduce (fig. 205) for windows, arches, and other openings that appear darkest in my photo reference. These areas can also be darkened with pencil, using very even strokes; the brush-and-water technique isn't strictly necessary to produce intense black tones. But however they are achieved, by making these openings black, the tonal value of the drawing as a whole is lowered.

To start developing the foreground, I darken both the unadorned poles and the striped ones with their decorative tops (fig. 206) that are so typical of the Venetian landscape. Here, as in the openings in the background, my deep blacks are drawn with water-soluble pencil, then dampened and gone over again with pencil to achieve a more intense black.

When I use pencil and brushed-on water to paint the gondolas (fig. 207), I apply mainly deep tones, but make some areas lighter grays, defining the top surfaces and rims of their forms. I also begin including cast shadows on the water just under the boats. Note that I haven't toned the water or sky as yet, intending to retain a good deal of their lightness in my final step.

205

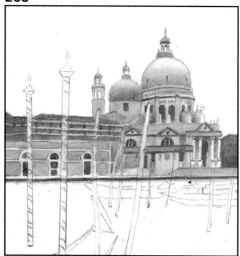

Figs. 205, 206, and 207. Contrasts are intensified by drawing door openings, windows, and the poles and boats in the foreground. Finally, with a fine sable brush and wash, I paint the reflections in the water.

206

207

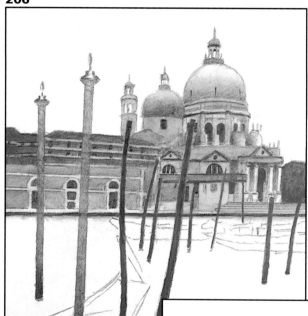

208

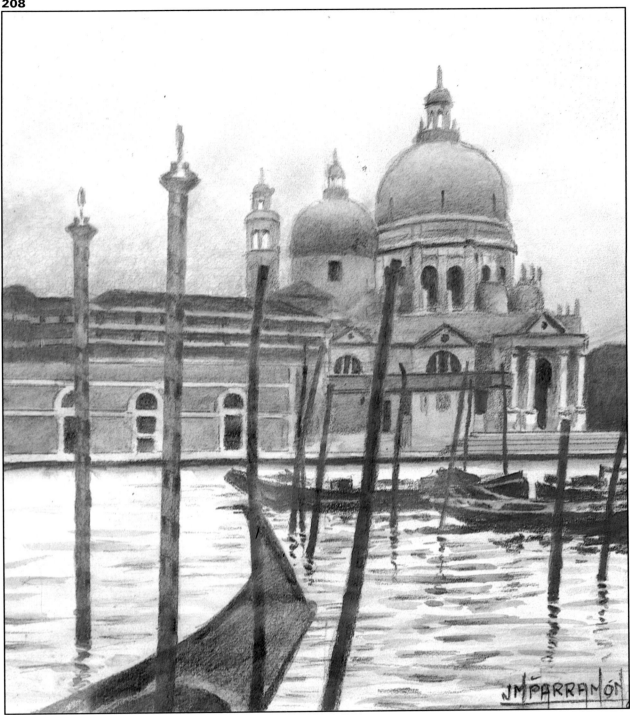

To paint the gently rippling water and reflection of poles and boats in it (fig. 208), I load my brush with graphite from the patch created earlier on a separate piece of paper, and apply it, using horizontal brushstrokes or varying widths and lengths. Water reflections can be tricky to draw or paint; practicing horizontal brush-strokes of this type is a good way to master the technique.

As for the sky, I decide to use only a very light wash on it, applied with my drawing turned upside down. Turning the paper around prevents droplets of water from falling on areas that have just been finished.

A final retouching of accents here and there—just lines of the pencil, no brush—completes my drawing.

Fig. 208. I'm proud of this finished drawing, which I think conveys the serenity and splendor of a beautiful Venetian scene.

Exercises for Rapid Sketching

A sketch is a drawing that may be made as a preliminary study that will later serve as reference for more finished work. A pocket-size sketchbook (fig. 209) is often used by the professional artist who is ever ready when inspiration impels recording subject matter of immediate interest. Sketch studies can also be considered works of art in themselves, such as these fine examples show (figs. 210, 211). In either case, the sketch is characterized by the reduction of a motif to its more basic elements.

When you practice sketching, your objective should be to avoid details and convey, instead, an overall impression of a subject and your interpretation of it. Ideally, sketches are drawn with broad strokes, giving form to objects with just a few free lines that are executed with speed, spontaneity, and close concentration.

But, what purpose does rapid sketching serve? Learning to draw well requires, above all, developing a keen power of observation. Sketching offers the best way to do that. Only by looking closely at the world around us can we develop the necessary communication between the eye, the mind, and the hand.

209

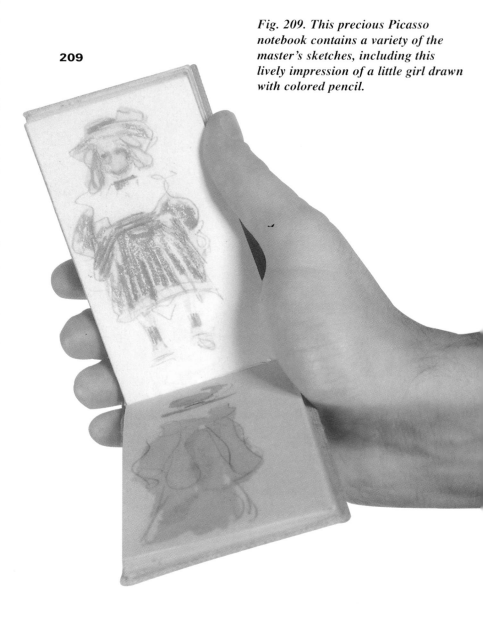

Fig. 209. This precious Picasso notebook contains a variety of the master's sketches, including this lively impression of a little girl drawn with colored pencil.

Fig. 210. These expert sketches of a baby boy and studies of his face in various positions were drawn by Francisco Bayeu.
Fig. 211. A sketch of a male nude by Merche Gaspar was rendered in long, quick pencil strokes.

210

211

212

213

214

Figs. 212, 213, and 214. Artist-teacher Merche Gaspar always carries a sketchbook with her in which she draws whatever attracts her attention, such as these fine examples of the human figure, animals, and a rural landscape.

It's important that your sketches reflect both the correct drawing of an object's structure and the play of light and shadow on it, in case you want to use the sketch as reference for more finished art. Many artists make notes next to sketches indicating colors, how light falls on objects, and other details that might be helpful at a later date when developing the material further.

Exercises in rapid sketching have double value: on the one hand, you get to practice the art of drawing from life; on the other hand, you activate your skills in layout, composition, contrast, and the interpretation of subject matter.

Follow the example of professionals by getting into the habit of carrying a small sketchbook with you at all times, together with a 6B pencil. Sketch the bowl of fruit (fig. 215) that you see on a friend's kitchen table; record your quick impression of little structures along the beach (fig. 216) or in the valley below you (fig. 217) as seen from your hotel balcony.

Vary your subject matter, so that by the time a sketchbook is filled, it contains people, places, and things. Sketch only single items sometimes—a chair, a bicycle, a single flower; other times, try action sketches or vignettes involving a few people or a grouping of inanimate objects. But no matter which subject matter you choose, if you practice sketching it, you are sure to acquire greater ease in drawing it.

215

216

217

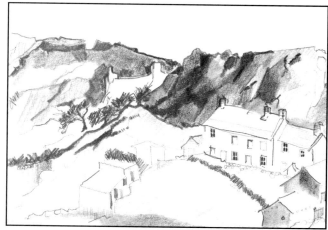

Figs. 215, 216, and 217. Bibiana Crespo, printmaker and teacher, prepared these strong sketches of a still life, a beach dotted with fishermen's shacks, and a mountain landscape.

Drawing Animals and Plants

218

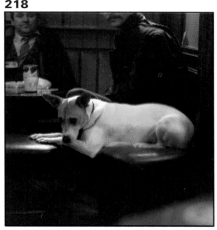

Fig. 218. The model for this drawing is a handsome dog lying in an old chair.

Figs. 219 and 220. Rapid sketching of animals requires figuring proportions very quickly—unless you're lucky enough to have a sleeping dog as your model, or are working from a photo.

219

220

In the next few exercises, you'll learn how the complex structure of animals and plants can be used as a point of departure for sketching. Since animals rarely stay still, using them as models offers good exercise in rapid sketching. And to sharpen your ability to observe things closely, sketching plants offers experience in capturing the complexity of subject matter with lots of details.

Artist Merche Gaspar was inspired by a photo of a handsome dog (fig. 218) as subject matter for the sketching exercise on this page, which she completed in under fifteen minutes.

After studying the photo carefully, Merche begins her sketch by holding her pencil loosely and going over the paper surface lightly to approximate the shape of the dog (fig. 219). The structure of her sketch consists of three parts, each based on a geometric form as a starting point: a triangle for the head; a cylinder for the body; and a sphere for the rounded haunch. Note how her lines are corrected here and there as she adjusts the position of the animal's body. In this first step, details such as facial features are only vaguely indicated.

Now the artist adds tone to establish form and volume (fig. 220), then defines the dog's eyes and ears. As a final touch, the whole figure seems to stand out in relief as soon as a gray background shadow is added.

It's practical to sketch dogs and cats from life when they're asleep. But don't worry if the animal wakes up before you've been able to finish your drawing. You'll find that dogs and cats often resume exactly the same position the next time they go to sleep, so you can finish your drawing later.

TIPS

Once you've had some practice sketching animals in repose, try to draw them in motion.

In action sketches, go for overall body gestures and ignore details.

Now we can see what happens when we try to draw animals that are in constant movement (fig. 221).

Merche Gaspar begins her sketch by drawing the outlines of the geese (fig. 222), using a series of overlapping lines of different intensities. She doesn't stop to put in any details at this point. Her first step is sketched very quickly.

With her pencil held slightly slanted, she emphasizes the shaded areas of the composition (fig. 223). Animals offer very rich textures to portray. Graphite is an especially apt medium for capturing texture, such as suggesting the smoothness of the birds' plumage with just a few pencil lines. The most important thing is for the drawing to be clear, simple, and deliberate.

To finalize her sketch (fig. 224), the artist details the webbed feet, the beaks, and adds touches of subtle shading.

221

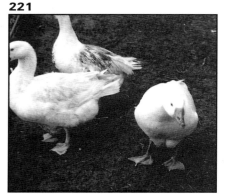

222

223

224

Fig. 221. Geese are restless animals that don't stop moving for even a minute, which means that Merche has to study them for a while in order to memorize their shapes and movements.
Figs. 222, 223, and 224. Artists who master drawing can sketch animals from memory, as these examples show. But many artists who need to work with a stationary model in front of them find photographic references to be very satisfactory substitutes.

225

226

To illustrate a more detailed sketching technique, Merche chooses to depict a tropical plant in its pot (fig. 225). The complicated, sinuous plant forms and range of tones, from very dark leaves to white floral petals, offer an ideal subject. For this exercise, use sheet number 10.

As Merche did with this exercise, when sketching plants, look at your subject from various vantage points before deciding which is best. Merche's choice emphasizes the interplay between the curve of the stem and the supporting stick.

Using a 2B pencil, she begins sketching (fig. 226). Her initial rendering vaguely defines the shape of the stem, leaves, and flowers with looping, free, and easy broken lines.

Her next pencil strokes are more emphatic (fig. 227) as she reinforces each part of the drawing with uninterrupted lines. To bring greater contrast to the drawing, she begins to tone areas within their outlines: the leaves of the plant, the pot, the stem.

Finally, the artist applies more contrasted tones (fig. 228) and introduces some especially intense shading surrounding the pretty white blossoms to make them stand out from their background (fig. 228).

227

228

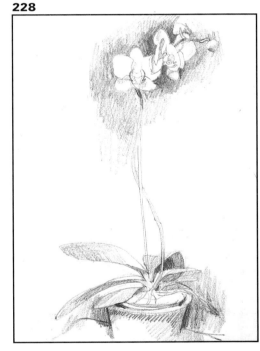

Fig. 225. An orchid plant in a ceramic pot provides simple, yet graceful subject matter for a drawing.
Fig. 226. A sinuous line describes the stem; a careful looping line, the blossoms; and a simple cylinder, the pot.
Figs. 227 and 228. Plants present the challenge of synthesis, bringing all the elements together cohesively. When you draw a plant, focus on the structure rather than the details.

TIPS

By keeping a background light and clean, shapes in front of it pop out at the viewer without having to compete with surrounding elements.

Where an important element of a drawing is very light but is lost against a background that is also very light, create shadows of a deeper value, as shown in the drawing above.

Glossary

Asymmetrical drawing: A drawing in which the structure and distribution of elements are not the same on both sides of an axis but, nevertheless, maintain a balance of one mass against another.

Atmospheric perspective: Perspective is affected by atmosphere, as successive layers of air cause objects at greater distance to become less distinct than nearer objects. In landscape drawing, the most distant mountains, trees, and structures have lightest tonal values; foreground objects have darkest values and are most defined.

Background: The area in a drawing that seems to be farthest from the viewer; objects behind the middle ground and foreground of a composition.

Backlight: Contrast caused when light hits an object from behind, creating an intense shadow on a luminous background.

Cast shadow: The shadow cast by one object onto something else in a picture, such as a vase casting its shadow on the table on which it sits.

Chiaroscuro: Italian for "light-dark," the technique of modeling form to give the impression of a third dimension through gradations of light and dark tonal values.

Composition: The placement of various elements of a drawing in the most balanced and harmonious way possible. Also referred to as layout.

Easel: A frame for supporting a sketchbook or support board, recommended when working on very large drawings.

Figure drawing: Drawing representing the human figure.

Fixative: A colorless solution sprayed onto artwork of impermanent materials such as charcoal and pastel; sometimes used on pencil drawings to prevent graphite powder from smudging.

Foreground: The bottom of a drawing, containing subject matter that seems to be closest in space to the viewer. Objects in the foreground are most clearly defined and usually the darkest in value.

Format: The size and proportions of a piece of drawing paper—usually horizontal, vertical, or square.

Geometric shapes: Used in a preliminary drawing to establish the general form of objects: cube, cylinder, sphere, or cone.

Golden section: Traditional proportions to achieve visual harmony, in which the ratio of the whole to the larger part is the same as the ratio of the larger part to the smaller.

Gradation: Diminishing the value of a tone, moving gradually from an intense to a lighter one, so that there is no abrupt transition.

Graphite: The most usual material of which pencils are made; the substance usually incorrectly referred to by its misnomer, "lead" pencil.

Intensity: Refers to the darkest values used in pencil drawing.

Kneaded eraser: A completely dustfree, malleable eraser that can be molded into any shape, such as a sharp point for erasing tiny areas of graphite. Pulling it like taffy increases its absorption and cleans its exterior surface.

Lead pencil: A misnomer for a graphite pencil.

Line drawing: A drawing made solely of lines, with no darkened areas or shadows.

Middle ground: The plane in a drawing that is midway between foreground and background space.

Modeling: A term used in sculpture, it also applies to drawing in describing the use of different tones to create the illusion of three dimensions.

Negative space: Empty space around or between objects in a composition.

Outline: An actual or imaginary line that marks the boundary of an object or figure, without taking into consideration light, shade, or internal modeling.

Perspective: The method of representing a three-dimensional object, or a volume of space, on a flat surface.

Scale: Proportion or measurement; something drawn "one-third scale" is drawn one-third the size of the original.

Scale drawing: A preliminary study that gives form to the basic structure of objects through simple geometric shapes: cubes, rectangles, cylinders, spheres.

Stump: A paper cylinder, pointed at each end, used for graying and grading lines or marks of graphite pencil.

Symmetry: Composition of a picture based on the repetition of elements on both sides of a single point or central axis.

Texture: The tactile and visual quality of the surface of a drawing: smooth, grainy, or rough,

Tonal value: In pencil drawing, the comparative brightness or dullness of lines and marks.

Tooth: Refers to the peaks and valleys formed by a paper's fibers. The rougher the paper surface, the more firmly pencil marks will cling to it.

Value: The relationship between tones, ranging from light to dark. In a drawing, a range of values is used to describe the effects of light and shadow on subject matter.

Viewfinder: Resembling a picture frame, but ususally made out of mat board, a device through which the artist views subject matter to determine how much of it to include in a drawing.

Wash: A hue or tint applied in a thin transparent layer. In pencil drawing, wash techniques can be achieved by working with water-soluble graphite pencils, whereby water is applied with a brush over selected areas of a drawing.

Permissions

The author wishes to thank the following for use of photographs. (Works are listed in order of their appearance in the book.)

Study for *Libyan Sibyl,* Michelangelo. Sistine Chapel, Vatican.

Head and Forearm, Raphael. Galleria degli Uffizi, Florence.

Study of Six Dogs, Antonio Pisanello. Louvre, Paris.

Sketchbook, Eugène Delacroix. Louvre, Paris.

Greek vase. National Archeological Museum, Athens.

Detail, Via Portuense tomb. Museo Nazionale Romano, Rome.

Anthropomorphic Alphabet, Giovanni de Grassi. Biblioteca Civica, Bergamo.

Utrech Psalter. Utrech Library, The Netherlands.

Scriptorium of the All Saints Monastery. Stadtbibliothek, Schaffhausen.

Study of Male Nude, Michelangelo. Royal Library, Windsor Castle.

Design for Arch of Triumph, Lodovico Cigoli. Galleria degli Uffizi, Florence.

The Story of Esau and Jacob, Benozzo Gozzoli. Museo delle Sinopie, Pisa.

Study of a Horseman, Adriaen van de Velde. Louvre, Paris.

Alpine Landscape, Roelant Savery. Louvre, Paris.

Portrait of Isabella Brandt, Peter Paul Rubens. Galleria degli Uffizi, Florence.

Portrait of John Hay and His Sister Mary, Jean-Auguste-Dominique Ingres. Louvre, Paris.

For Descending from Jews, Francisco de Goya. Museo del Prado, Madrid.

Study, Henri de Toulouse-Lautrec. Musée de Toulouse-Lautrec, Albi.

Madonna de Port Lligat, Salvador Dalí. Private collection, Paris.

Spanish Woman with Fan, Henri Matisse. Musée de Luxembourg.

Celia, David Hockney. Collection of the artist.

Nude Girl Reclining, Egon Schiele. Nueu Galerie am Indesmuseum, Graz.

Pencil study for *The Turkish Bath,* Jean-Auguste-Dominique Ingres. Louvre, Paris.

Portrait of the Artist's Sons, Hans Holbein. Staatliche Museum Preussischer Kulturbesitz, Berlin.

Landscape in Pencil, Enrie Ferau Alsina. Joan Casellas Collection, Museo Nacional de Arte de Cataluña, Barcelona.

Head of the Apostle Saint Mark, Albrecht Dürer. Staatliche Museum Preussischer Kulturbesitz, Berlin.

Self-Portrait, Maurice Quentin de La Tour, Louvre, Paris.

View of Omval, Rembrandt van Rijn. Bibliotèque Nationale, Paris.

Blessed Virgin, Albrecht Dürer. Germanisches Nationalmuseum, Nuremberg.

The Fall of the Damned, Peter Paul Rubens. British Museum, London.

Basket with Cloth, Francisco Bayeu. Museo del Prado, Madrid.

East Bergholt Church, John Constable. Spooner Collection, The Courtauld Institute Galleries, London.

Academic Study, Francisco Bayeu. Museo del Prado, Madrid.

Sketch with Grid, Edgar Degas. Louvre, Paris.

Notebook Sketch, Pablo Picasso. Museo Picasso, Barcelona.

Nude Boy and Four Head Studies, Francisco Bayeu, Museo del Prado, Madrid.

Acknowledgments

The author of this book is grateful to the following individuals and businesses for their collaboration on the publication of this volume in the Techniques and Exercises series. Thanks to Gabriel Martín Roig for his contributions to the text and for the general coordination of this book; to Antonio Oromí for photography; to Vicenç Piera of the Piera firm for his advice about tools and materials for painting and drawing; to Manel Ubeda of the Novasis firm for the layout and design; and, most particularly, to the artists Bibiana Crespo, Merche Gaspar, Ester Llaudet, Pere Llobera, and Ginés Quiñonero for providing the step-by-step exercises.

1

2

3

4

5

6

7

8

9

10

	A	B	C	D	E	F	G	H
1								
2								
3								
4								
5								
6								
7								
8								
9								
10								